ELLE STYLE
The 1980s

STYLE

ELLE

The 1980s

JEAN DEMACHY - FRANÇOIS BAUDOT

filipacchi
publishing

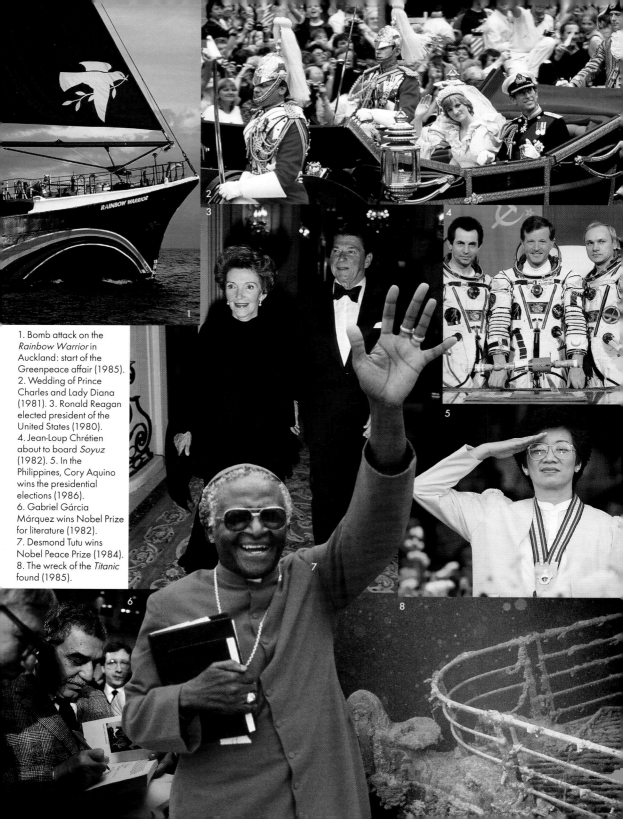

1. Bomb attack on the *Rainbow Warrior* in Auckland: start of the Greenpeace affair (1985). 2. Wedding of Prince Charles and Lady Diana (1981). 3. Ronald Reagan elected president of the United States (1980). 4. Jean-Loup Chrétien about to board *Soyuz* (1982). 5. In the Philippines, Cory Aquino wins the presidential elections (1986). 6. Gabriel Gárcia Márquez wins Nobel Prize for literature (1982). 7. Desmond Tutu wins Nobel Peace Prize (1984). 8. The wreck of the *Titanic* found (1985).

ven though the 1980s were known as the Greed Decade, fashion experts would probably refer to it as the decade of individualism and extremes. Marked by such trends as power-dressing, cross-dressing and status-dressing, the invention of high-tech fabrics, the use of vibrant colors and abstract-expressionist graphic prints, the Japanese invasion, the birth of the graffiti, logos, street-wear and hip-hop, the popularity of preppy-punk and hyper-accentuated silhouettes with shoulder pads the size of the rock of Gibraltar, the '80s was one of the most creative and outrageous periods of fashion in the 20th century.

here did '80s fashion extremism come from? Historians and social critics like to make sense of shifting cultural tides by holding up the pendulum as a metaphor. Designers and fashion experts would protest that the pendulum doesn't swing fast enough for their tastes, but one could argue that without the Me Decade (the '70s) that preceded it, there would never have been the Greed Decade, where the zeitgeist of the times shot sharply away from self-reflection to self-indulgence. In the United States the '70s gave us the explosion of pop-psychology, feminism, the sexual revolution and a youth movement that fed off the social and political crises of the race riots in Detroit and Los Angeles, and a burgeoning anti-war movement that sowed the seeds for Watergate. The '70s was a decade where the whole nation, young and old, embraced the values of the social revolution of the '60s and

a keen sense of irony ruled the day. It seems quite natural, then, that so many years of extreme self-examination and facile values would give way to a period of self-expression and grandstanding that was turbo-charged by confidence scams, Wall Street and cocaine-inflated egos. Whereas the '70s gave us pet rocks, free love, synthetic fabrics, disco, smiley faces and smiley drugs, the '80s spawned status symbols such as rolodexes, red Ferraris, trophy wives, private jets, break dancing, New Wave and Max Headroom.

In the U.S. the advent of the technology industry and a booming economy gave birth to more bravado, hubris and extravagance than this country had seen since the industrial revolution. The climate was one of exponential excess, and quite naturally, fashion reflected societal extremes. On the one hand there was the birth of hip-hop and the wholesale adoption of street culture as a legitimate source of inspiration. In fashion, the punk movement gave way to the New Romantics which led to over-accentuated hourglass shapes epitomized by those lethal-looking femme fatales in Robert Palmer's "Addicted to Love" video.

Politically, the '80s saw a crumbling of barriers from the Berlin Wall to the nascent beginnings of Perestroika in Moscow. But culturally, thanks to the stock market, which shifted most of the country's wealth into the

hands of only 10% of the country's population, the media did more to define style than any other decade before. Movies like *American Gigolo, Blade Runner, Rumble Fish, Sid and Nancy, She's Gotta Have It, Blue Velvet, Wall Street* and *Working Girl* were a testament to the times and trends that went with them. John Hughes's films *The Breakfast Club* and *Pretty in Pink* made Molly Ringwald the poster-girl of the Greed Decade, while Bret Easton Ellis's bestseller *Less Than Zero* summed up the meaning of life (or lack of it) for the ennui-entrenched rich kids of Beverly Hills.

In 1980, the year that launched MTV, the world lost one of its greatest musical icons when John Lennon was murdered. The tragedy seemed to mark a turning point away from pop and folk rock toward the artifice of club music and cross-dressing with such bands as Boy George and Culture Club, Frankie Goes to Hollywood, Prince, Grace Jones, The Cure, the Pet Shop Boys and The Smiths.

The birth of the compact disc and the release of Madonna's "Holiday" in 1983 were followed by Michael Jackson's "Thriller" and Bruce Springsteen's "Born to Run." All of these musicians—especially Madonna with her magpie baby-doll dresses and leather biker jackets, workboots and piles of gothic jewelry and rubber band bracelets—legitimized street fashion

as a viable commercial segment of the fashion industry. And now more than ever, we see the influence that the birth of hip-hop in the '80s with artists like Run DMC, Grandmaster Flash and Public Enemy had on the changing face of fashion. Most of what John Galliano, who graduated from Central St. Martins in 1984, designs for the house of Christian Dior today, has its roots in a culture born on the streets of Harlem in New York City.

Television also played a vital role in championing and influencing '80s fashion. Who could forget the Ungaro- and Valentino-clad catfights of Linda Gray and Victoria Principal in *Dallas* and Joan Collins and Linda Evans in *Dynasty* or the Armani-esque pastel suits worn by Don Johnson and Phillip Thomas-Thomas on *Miami Vice*. And as much as '80s fashion was geared toward excess, you could also say its obsession with body-fitting silhouettes, thanks to the invention of Lycra, was symbolic of the nation's fitness craze. Movies like *Flash Dance*, which parlayed the slashed sweatshirt and leggings into the fashion hall of fame, and *Perfect*, which starred Jamie Lee Curtis and John Travolta, chronicled the new body consciousness. This new aerobic culture was epitomized on the one hand by the ubiquitousness of white Reebok high-tops and leggings, and in other more refined circles, the flesh-hugging designs of Paris-based, Tunisian born designer Azzedine Alaïa. Who could forget the seminal '80s fashion

moment in Guns & Roses "November Rain" video with supermodel Stephanie Seymour encased in her ace-bandage Alaïa dress? It's no wonder Alaïa was crowned the "King of Cling" after he launched his line of couture-cut skintight dresses, skirts and tops in 1982?

Paris was the center of fashion during the '80s, but New York and London had their moments. In London, fashion as a form of protest continued to draw its inspiration from the streets, as the Punk Rock movement of the late '70s and early '80s, heralded by Vivienne Westwood and Malcolm McLaren, morphed into the New Romantic period. Westwood's Buffalo Girl collection of 1982 can best be remembered as the uniform of early '80s ethno-pop band Bow Wow Wow. The idea of words in print—one of fashion's biggest trends today—was originally the brainchild of British designer Katherine Hamnett, and British Duo, Stevie Stewart and David Holah, who under the name Body Map were the first to design dance wear as fashion with cut-out details. Both were all the rage in London, as its fashion scene experienced a renaissance.

And Stateside, while President Ronald Reagan's wife, Nancy was gracing the television in her signature tomato-red suits and dresses, coining the color "Nancy Reagan red," Andy Warhol was busy consummating the

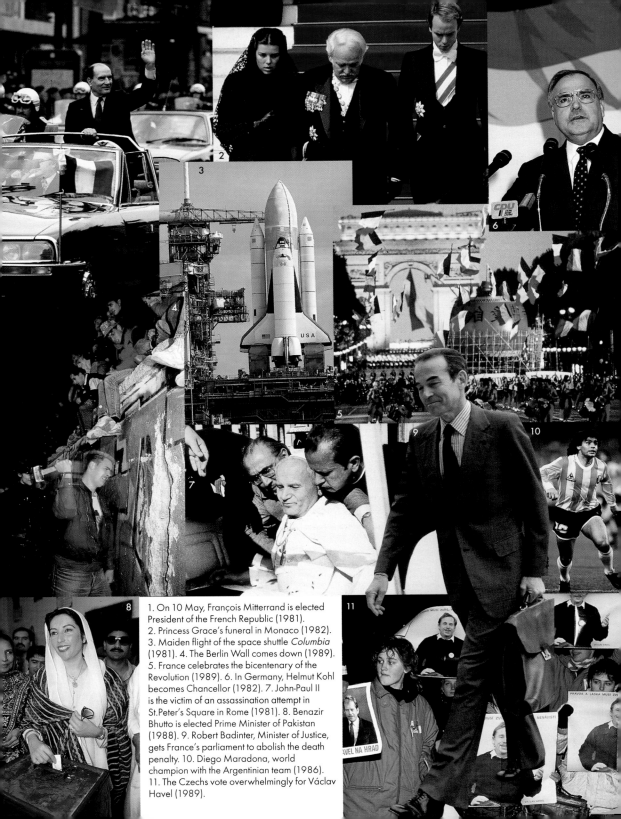

1. On 10 May, François Mitterrand is elected President of the French Republic (1981).
2. Princess Grace's funeral in Monaco (1982).
3. Maiden flight of the space shuttle *Columbia* (1981). 4. The Berlin Wall comes down (1989).
5. France celebrates the bicentenary of the Revolution (1989). 6. In Germany, Helmut Kohl becomes Chancellor (1982). 7. John-Paul II is the victim of an assassination attempt in St.Peter's Square in Rome (1981). 8. Benazir Bhutto is elected Prime Minister of Pakistan (1988). 9. Robert Badinter, Minister of Justice, gets France's parliament to abolish the death penalty. 10. Diego Maradona, world champion with the Argentinian team (1986). 11. The Czechs vote overwhelmingly for Václav Havel (1989).

marriage of uptown sophisticates with downtown artists. Club kids reigned supreme at venues like Limelight, Area and The World in outfits made at home that gave new meaning to the post-punk ethos "Just do it" that would be adopted by Nike as their signature ad campaign in 1988.

Before the AIDS crisis and the stock market crash devastated New York City and the world in 1987, American artists tuned into fashion's kinetic wavelength and commented on the gestalt of commercial fashion. Keith Haring mass-produced his urban graffiti characters by selling T-shirts and paraphernalia on the streets of lower Manhattan, and Barbara Kruger summed up the decade's retail-therapy pathos with her poster-work phrases, "I shop, therefore I am" and "Protect me from what I want." Wunderkind Stephen Sprouse went one step further, bringing the bravado of the streets to the forefront of fashion circles, when he launched a line of neon suits and glow-in-the dark graffiti-print dresses. The movie that best summed up the downtown fashion scene in the '80s was *Desperately Seeking Susan,* along with a film version of Tama Janowitz's novel *Slaves of New York.*

But Paris was truly the epicenter of '80s lavishness and wit. Designer Christian Lacroix launched his collection in 1982 and became an instant smash hit for his expressionist prints. In 1983, Karl Lagerfeld left Chloe

to become artistic director at Chanel, and Franco Moschino launched his first collection, sending model Pat Cleveland down the runway in a satin gown with sneakers and paper grocery bag. That same year Swatch launched its watches with the tagline "fashion that ticks." And while Nancy Reagan was introducing us to her "Just Say No" anti-drug campaign, wunderkind Jean Paul Gaultier was designing underwear to be worn as outerwear.

The following year, while Donna Karan introduced the bodysuit to thousands of working women in New York with the launch of her new collection, Apple debuted the first Macintosh computer. In 1985, the U.S. government outlawed the drug ecstasy, Dolce & Gabbana began their love affair with the Sicilian woman, and Gaultier, being Gaultier, turned all notions of propriety on its head and designed skirts for men. That same year, ELLE magazine launched in the U.S., and thanks to photographer Gilles Bensimon's graphic images, became an instant sensation. The year of the stock market crash, 1987, saw most Wall Street wives fighting by hook or crook to get one of Lacroix's pouf skirts, even as their husband's fortunes vanished overnight. This was also the year in which Andy Warhol and Fred Astaire died, and the world population reached 5 billion. The '80s ended with the Berlin Wall coming down, students protesting in Tiananmen Square, the launch of Versace couture and the death of editrix extraordinaire, Diana Vreeland.

The fashion cry—as the '80s gave way to the stark minimalism of the '90s and the iconic, controversially thin Kate Moss-type heroin chic—was "Thank God that's over. I don't ever want to wear shoulder pads again!" But fashion in the '90s became a whirlwind of retro-inspired trends that left the industry's confidence at a very low ebb. Designers seemed to search for a direction that would revitalize and reinvent fashion once again. As we approached and then reached the new millennium, not one design house had answered the proverbial question, "What new ideas will the 21st century bring?" In fact, it almost seemed designers gave up tackling innovation and invention at all.

Karl Lagerfeld once said, "You can't do something new by doing the same old thing badly," and thanks to a handful of designers like John Galliano, Nicolas Ghesquière, Marc Jacobs, Alexander McQueen, Tom Ford, Narciso Rodriguez, Giambattista Valli, Olivier Theyskens, Véronique Branquinho, Phoebe Philo, Hussein Chalayan, Alber Elbaz, Viktor & Rolf and New York newcomers Jack McCollough and Lazaro Hernandez for Proenza Schouler, the talent coffers feel full again and the future looks bright. And, of course, '80s originals Karl Lagerfeld, Jean Paul Gaultier, Rei Kawakubo, and Yohji Yamamoto still lead the way with their creativity and vision. But now there is even a younger crop of new young designers who

are looking to the past for inspiration, and out of the whole cultural jumble that was the 20th century have zeroed in on the Greed Decade as the one they can relate to best.

So here we are in the year 2003 and those of us who swore we'd never look back now find that the '80s are bigger than ever. Broad-shouldered suits, punk influences, gothic influences, the stark intellectualism of the Japanese, graffiti bags by Stephen Sprouse for Marc Jacobs at Louis Vuitton, pencil skirts, colored tights, jersey slash dresses and anything resembling an Azzedine Alaïa are once again hot trends. Even the super-models of the '80s are taking to the runway again at shows in Europe and the U.S.

Fashion sages say of trends: If you've worn something the first time around, you should never wear it on its return. But somehow there's something irresistible about the '80s reprise. Clubs are playing '80s hits, there's a whole new crop of status symbols from *bing-bling* to *Hummers* that seem startlingly new but oddly familiar at the same time. Oh, and of course, we're once again in the middle of a stock-market downturn. Yet, funnily enough, even to this reporter's eye who wore it the first time (and who always keeps Karl Lagerfeld's astute observations in mind), every-thing '80s looks new again.

Anne Slowey

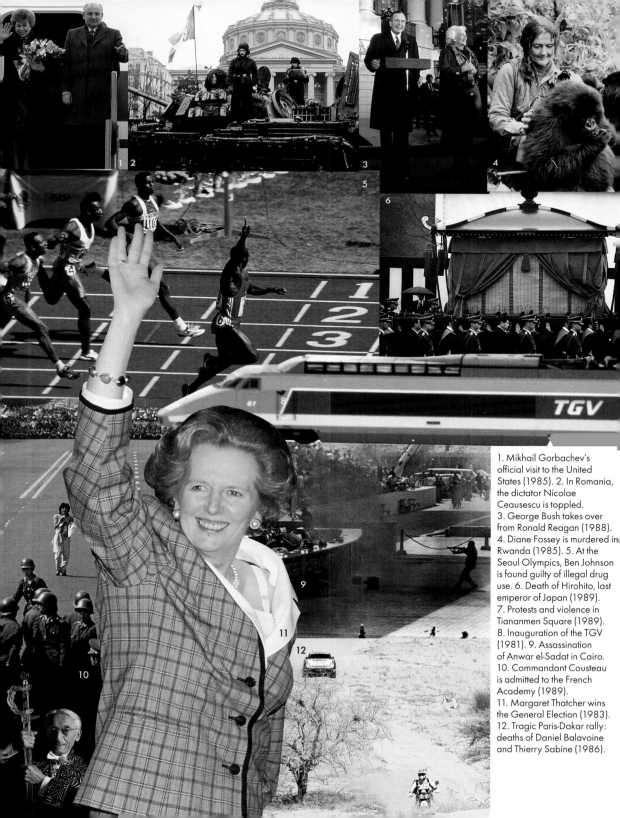

1. Mikhail Gorbachev's official visit to the United States (1985). 2. In Romania, the dictator Nicolae Ceausescu is toppled. 3. George Bush takes over from Ronald Reagan (1988). 4. Diane Fossey is murdered in Rwanda (1985). 5. At the Seoul Olympics, Ben Johnson is found guilty of illegal drug use. 6. Death of Hirohito, last emperor of Japan (1989). 7. Protests and violence in Tiananmen Square (1989). 8. Inauguration of the TGV (1981). 9. Assassination of Anwar el-Sadat in Cairo. 10. Commandant Cousteau is admitted to the French Academy (1989). 11. Margaret Thatcher wins the General Election (1983). 12. Tragic Paris-Dakar rally: deaths of Daniel Balavoine and Thierry Sabine (1986).

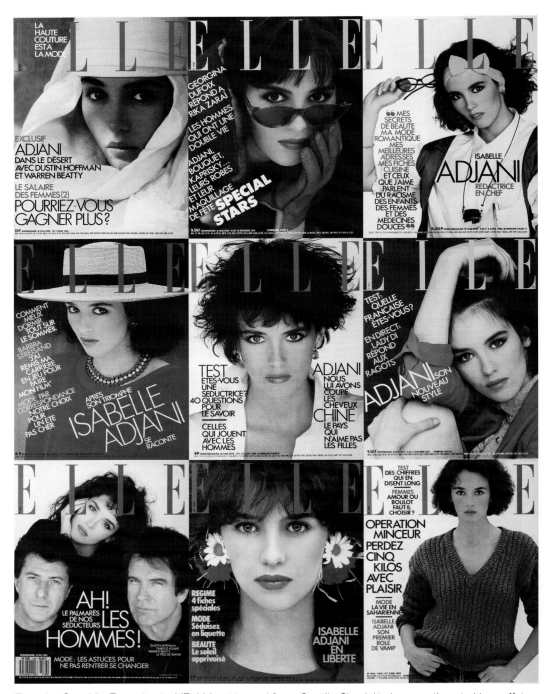

From the Comédie Française to *L'Eté Meurtrier,* and from *Camille Claudel* to her own thwarted love affairs, Isabelle Adjani has embodied the face of France for two decades. After scandalous Bardot and oh-so-

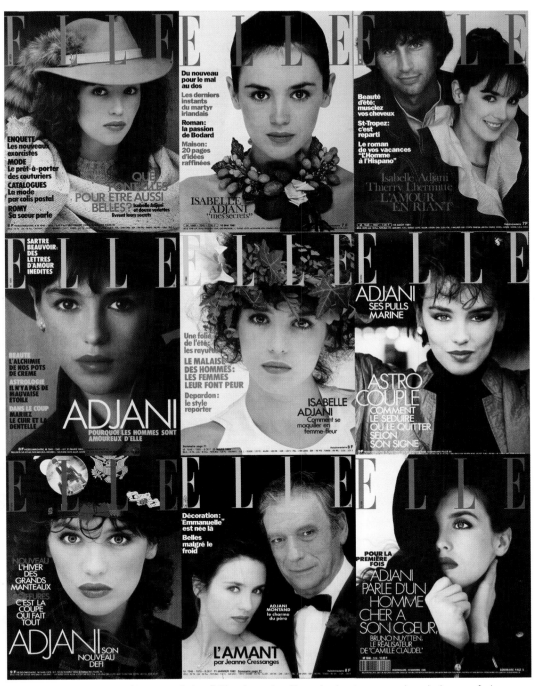

French Deneuve, it was this young lady of Algerian extraction who best conveyed a whole era of elegance and contradiction, talent and drama, be it on-screen or off.

1980 ► **Israel** grants **Egypt** two-thirds of **Sinai Peninsula** under terms of 1979 peace treaty. Death of **Alfred Hitchcock**, April 29. World record: **Björn Borg** wins **Roland-Garros** tennis tournament for the fifth time, May 26. Death of **Jean-Paul Sartre**: 20,000 people attend his funeral. **Louis Malle** marries **Candice Bergen**, September 27. **UNICEF** estimates that **20 million Africans** are threatened by famine. **John Lennon** of the **Beatles** is shot dead in NYC, December 8. Cost of a **U.S. first-class stamp**: $0.15. World Health Organization declares **smallpox** eradicated.

1981 ► **AIDS** is first identified by immunologist **Michael Gottlieb**, June 5. **Hugh Hudson** wins Oscar for Best Picture with **Chariots of Fire**. Marriage of **Prince Charles** and **Lady Diana**, July 29. **MTV** goes on the air with **round-the-clock videos**, August 1. **IBM** introduces the **Personal Computer** (PC), released in September. The 236-m.p.h. **TGV**, Europe's first **high-speed passenger train**, begins operating publicly, September 27. **Martial law** is declared in Poland by **Jaruzelski**, December 13.

1982 ► **Great Britain** overcomes Argentina in **Falklands War**, April 2-June 15. Grace Kelly, **Princess of Monaco**, dies in Monte Carlo, September 14. At the **movies**: Ettore Scola's **That Night in Varennes**, Richard Attenborough's **Ghandi**, and Spielberg's big hit, **E.T. - The Extra-Terrestrial**. **Michael Jackson** releases **Thriller** which sells more than **25 million copies**, becoming biggest-selling album in history. World's first **artificial heart,** the Jarvik 7, is implanted in **Barney B. Clark**, December 2.

1983 ► **Ronald Reagan** launches **Star Wars** program. Spielberg's **Return of the Jedi** is top movie moneymaker for the year. End of **Argentine dictatorship**. An estimated **105 million viewers** tune in to the last episode of **M*A*S*H**. Alice Walker's **The Color Purple** wins Pulitzer Prize. U.S. and Caribbean **troops** invade Granada, October 25. **Dr. Martin Luther King Day** is created as a U.S. national holiday. Death of **Joan Miró**, December 25.

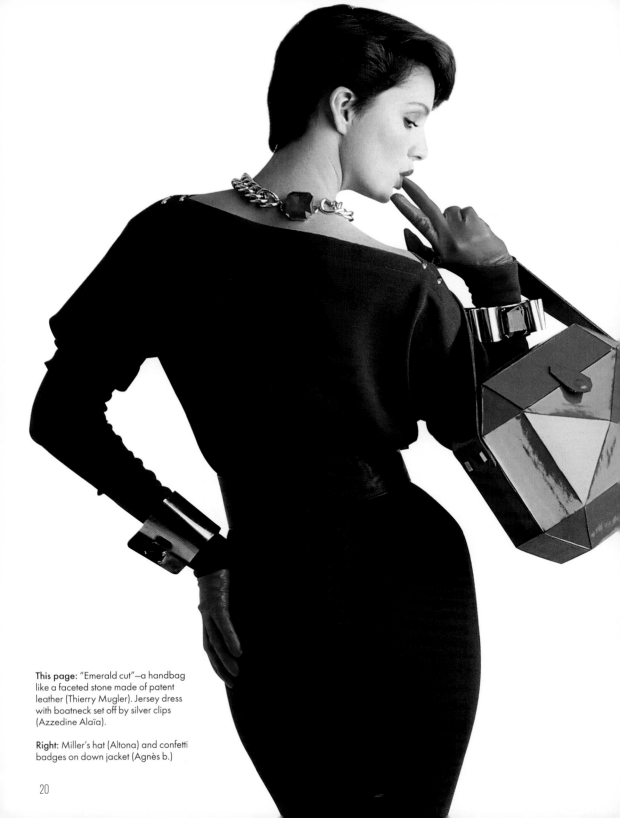

This page: "Emerald cut"—a handbag like a faceted stone made of patent leather (Thierry Mugler). Jersey dress with boatneck set off by silver clips (Azzedine Alaïa).

Right: Miller's hat (Altona) and confetti badges on down jacket (Agnès b.)

20

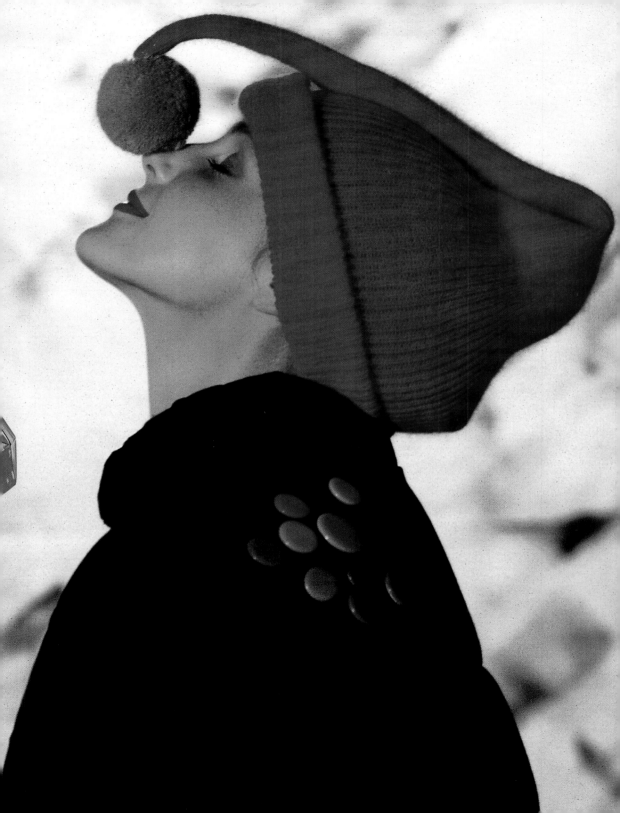

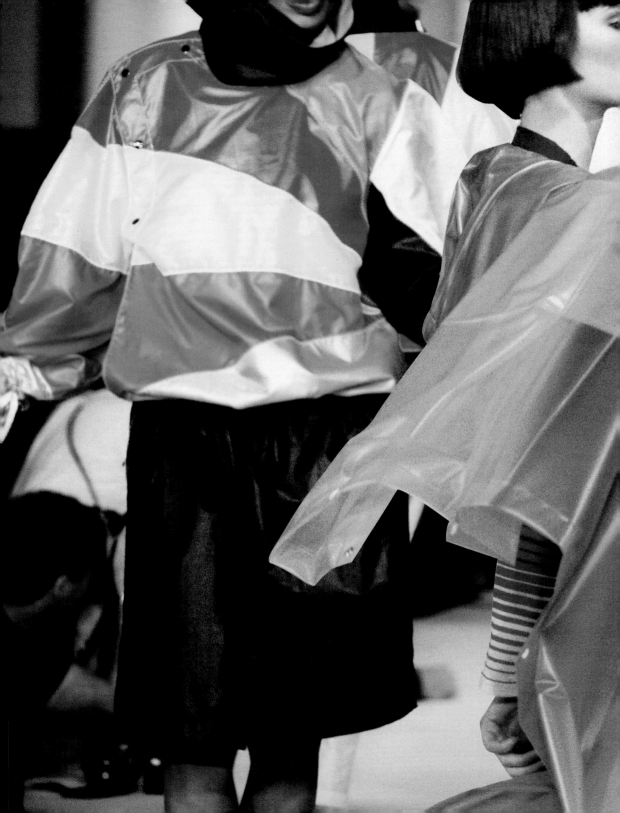

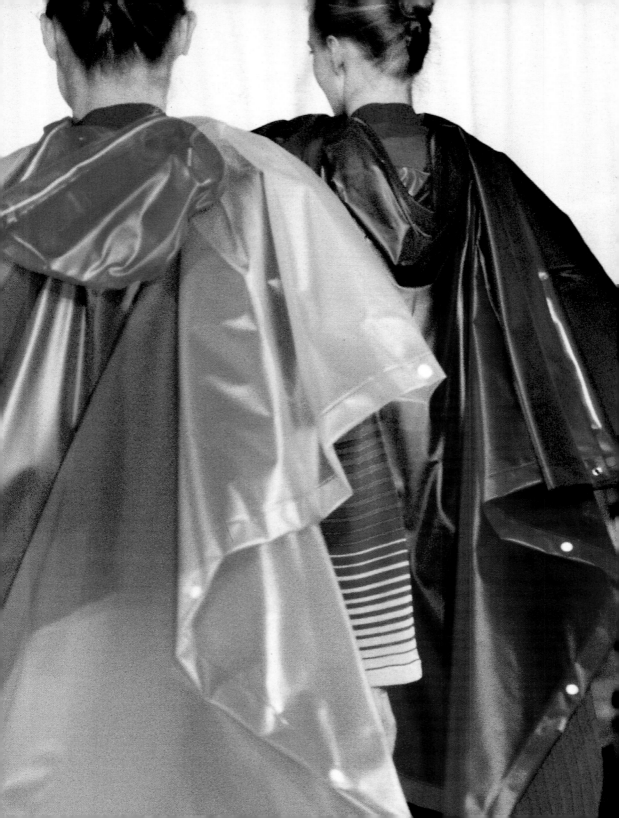

Previous pages:
New inspiration for the plastic arts, Popy Moreni's merry ponchos.
This page: Shiny smock and pants by Anne-Marie Beretta.

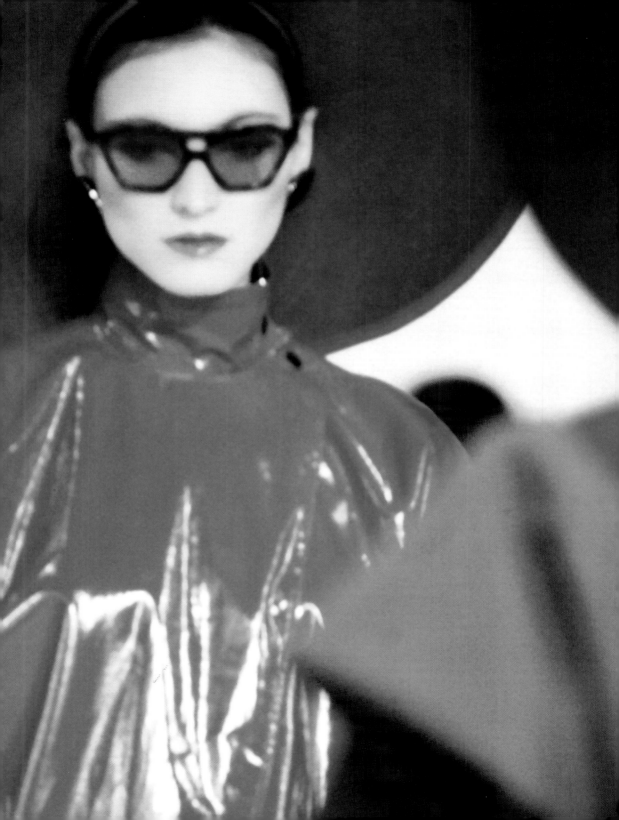

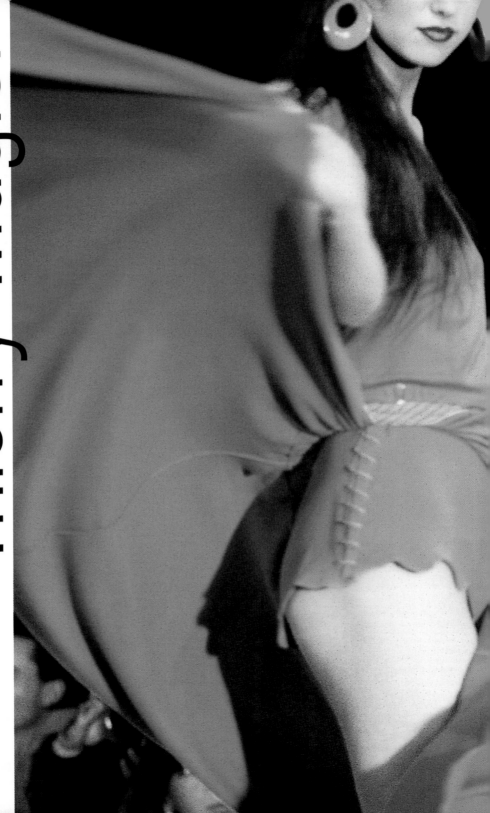

Thierry Mugler

Star couturier Thierry Mugler with one of his creations: a wide skirt over a ragged-edge cotton jersey leotard.

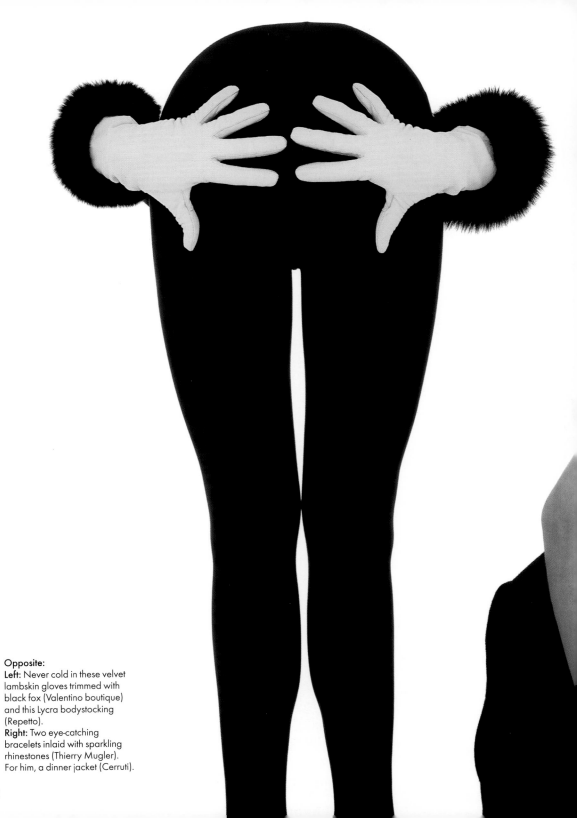

Opposite:
Left: Never cold in these velvet lambskin gloves trimmed with black fox (Valentino boutique) and this Lycra bodystocking (Repetto).
Right: Two eye-catching bracelets inlaid with sparkling rhinestones (Thierry Mugler). For him, a dinner jacket (Cerruti).

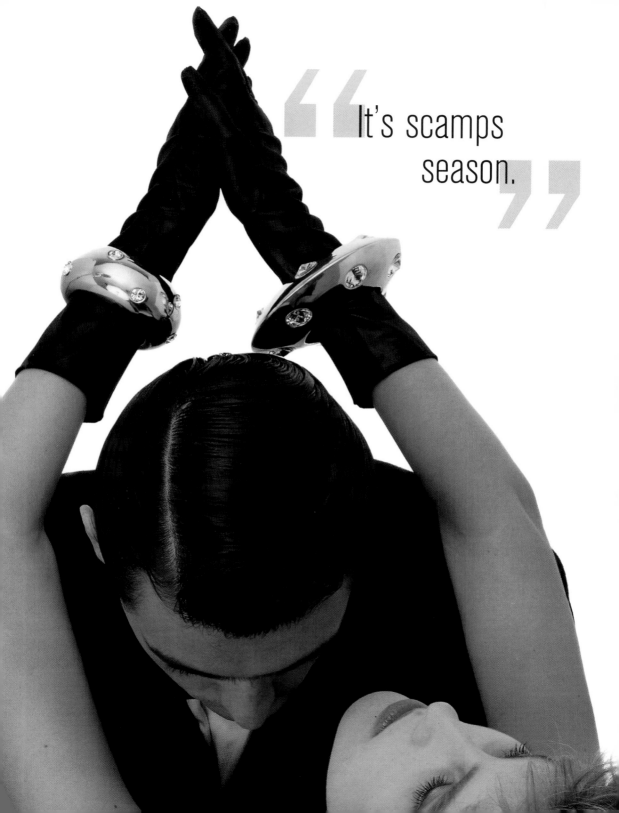

"It's scamps season."

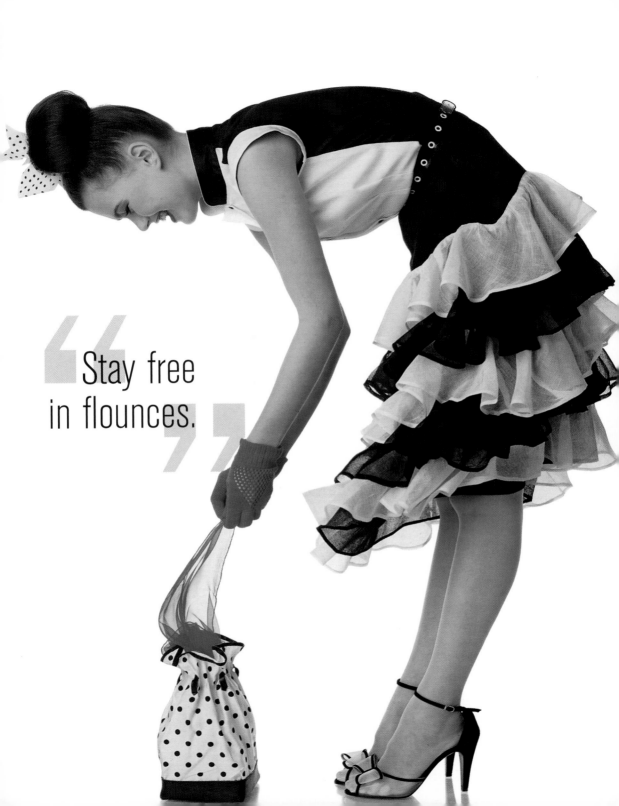

"Stay free in flounces."

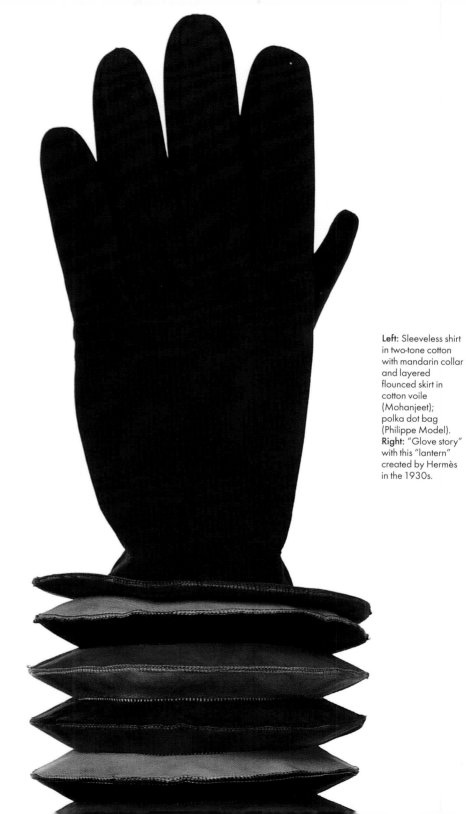

Left: Sleeveless shirt
in two-tone cotton
with mandarin collar
and layered
flounced skirt in
cotton voile
(Mohanjeet);
polka dot bag
(Philippe Model).
Right: "Glove story"
with this "lantern"
created by Hermès
in the 1930s.

31

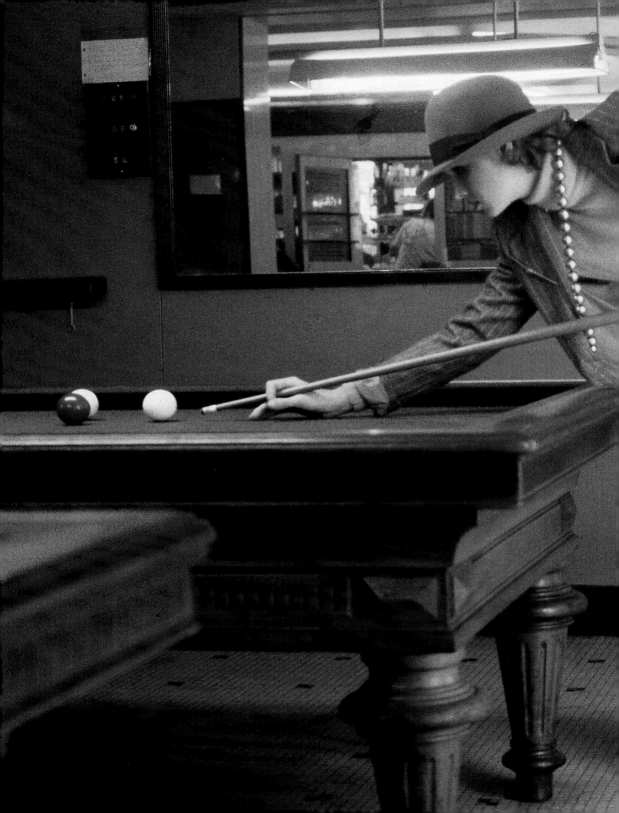

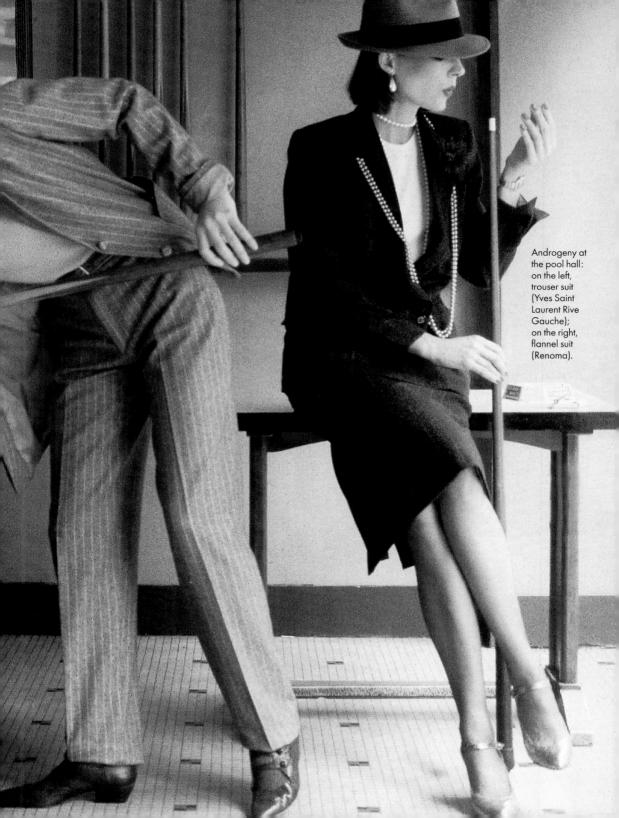

Androgeny at the pool hall: on the left, trouser suit (Yves Saint Laurent Rive Gauche); on the right, flannel suit (Renoma).

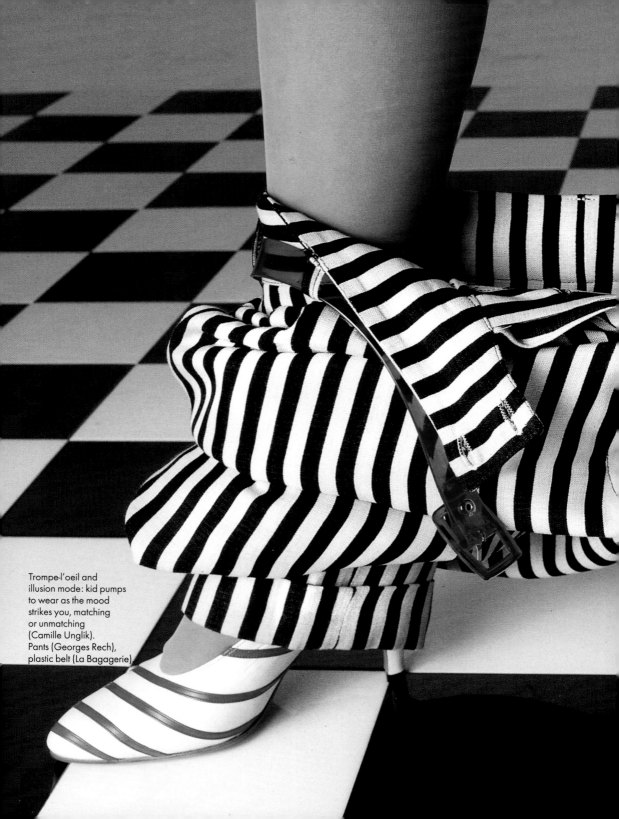

Trompe-l'oeil and
illusion mode: kid pumps
to wear as the mood
strikes you, matching
or unmatching
(Camille Unglik).
Pants (Georges Rech),
plastic belt (La Bagagerie)

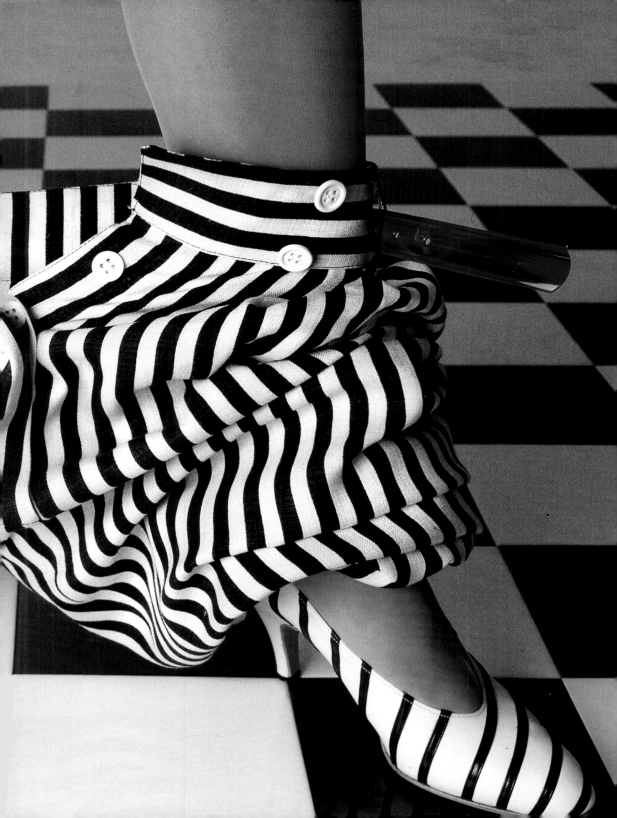

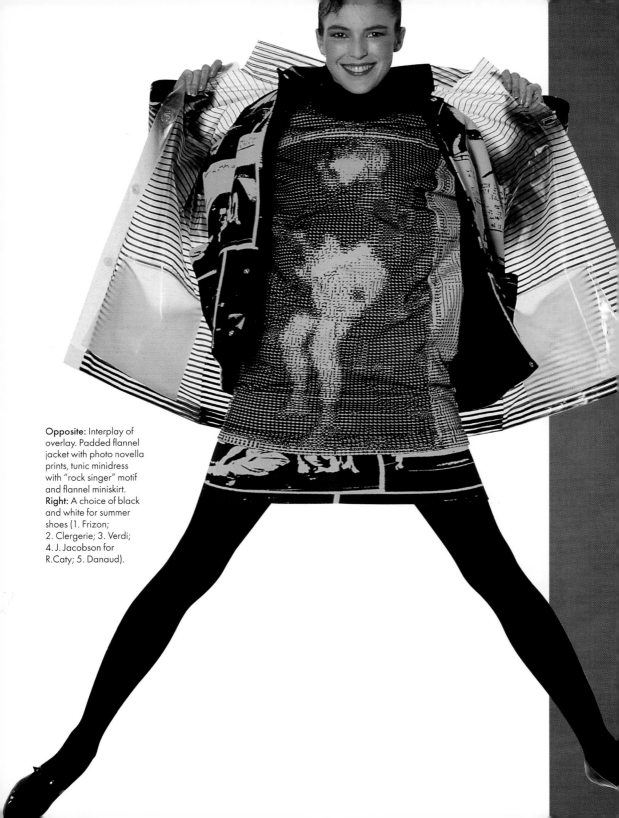

Opposite: Interplay of overlay. Padded flannel jacket with photo novella prints, tunic minidress with "rock singer" motif and flannel miniskirt.
Right: A choice of black and white for summer shoes (1. Frizon; 2. Clergerie; 3. Verdi; 4. J. Jacobson for R.Caty; 5. Danaud).

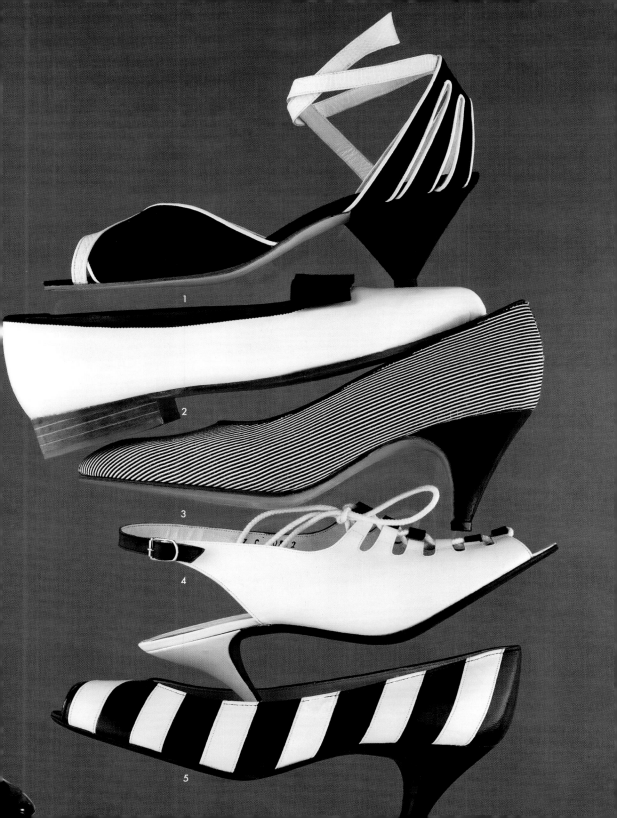

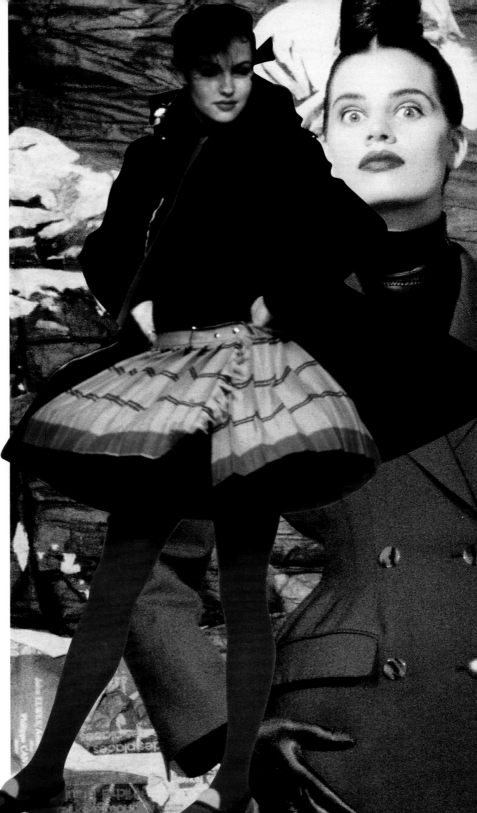

Jean Paul Gaultier

The enfant terrible of fashion.
Opposite: The classic kilt updated by Gaultier, wool bodystocking with roll-neck.
In the background: Extravagant look produced by Gaultier.

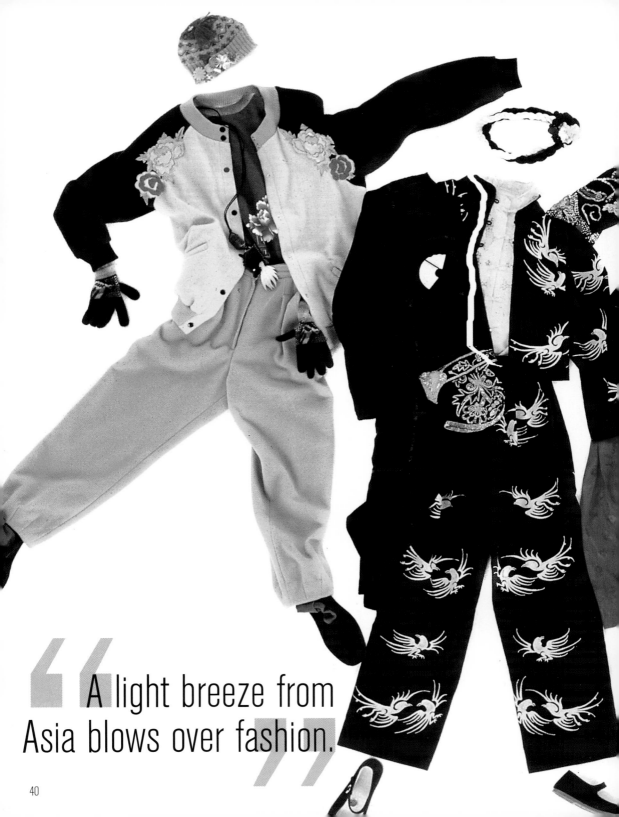

" A light breeze from Asia blows over fashion. "

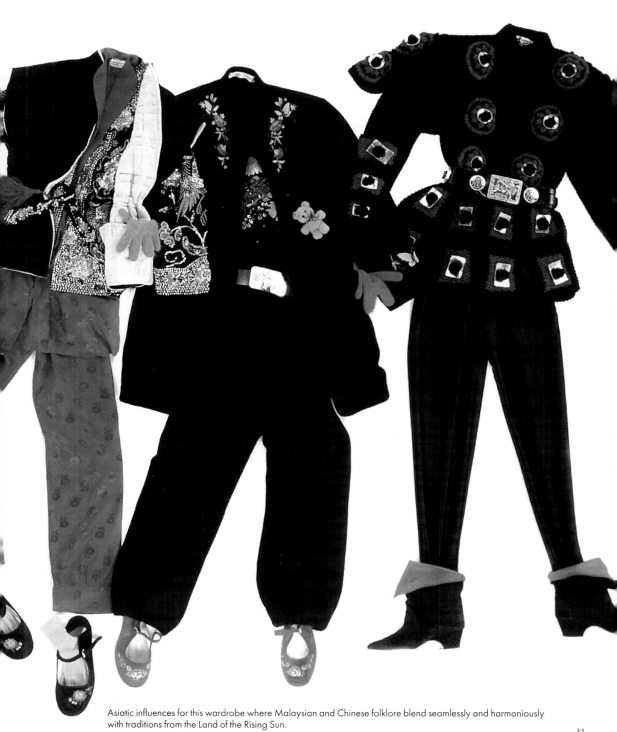

Asiatic influences for this wardrobe where Malaysian and Chinese folklore blend seamlessly and harmoniously with traditions from the Land of the Rising Sun.

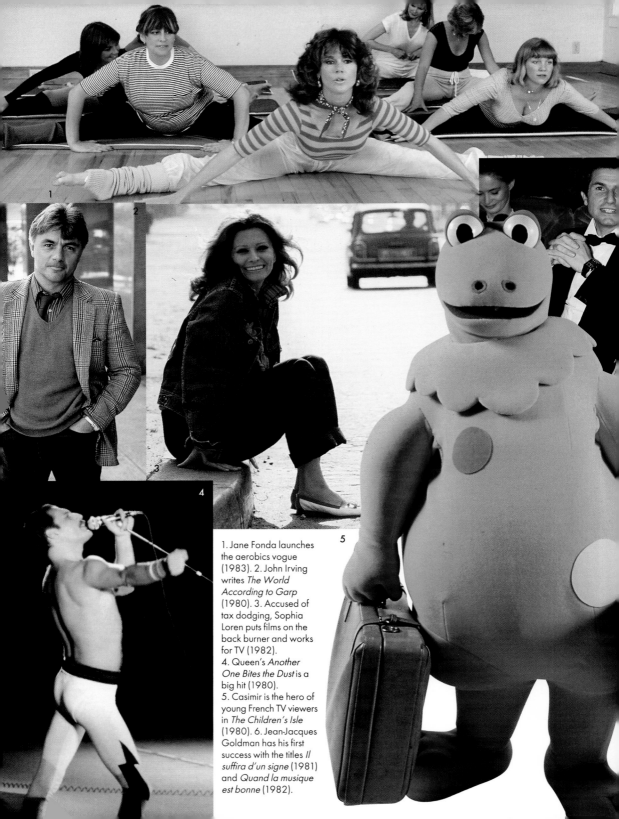

1. Jane Fonda launches the aerobics vogue (1983). 2. John Irving writes *The World According to Garp* (1980). 3. Accused of tax dodging, Sophia Loren puts films on the back burner and works for TV (1982).
4. Queen's *Another One Bites the Dust* is a big hit (1980).
5. Casimir is the hero of young French TV viewers in *The Children's Isle* (1980). 6. Jean-Jacques Goldman has his first success with the titles *Il suffira d'un signe* (1981) and *Quand la musique est bonne* (1982).

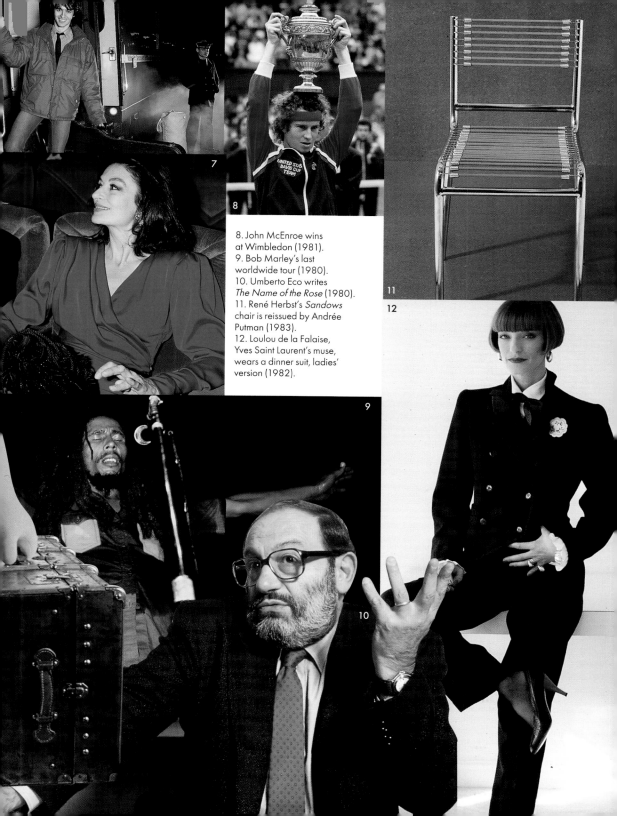

8. John McEnroe wins
at Wimbledon (1981).
9. Bob Marley's last
worldwide tour (1980).
10. Umberto Eco writes
The Name of the Rose (1980).
11. René Herbst's *Sandows*
chair is reissued by Andrée
Putman (1983).
12. Loulou de la Falaise,
Yves Saint Laurent's muse,
wears a dinner suit, ladies'
version (1982).

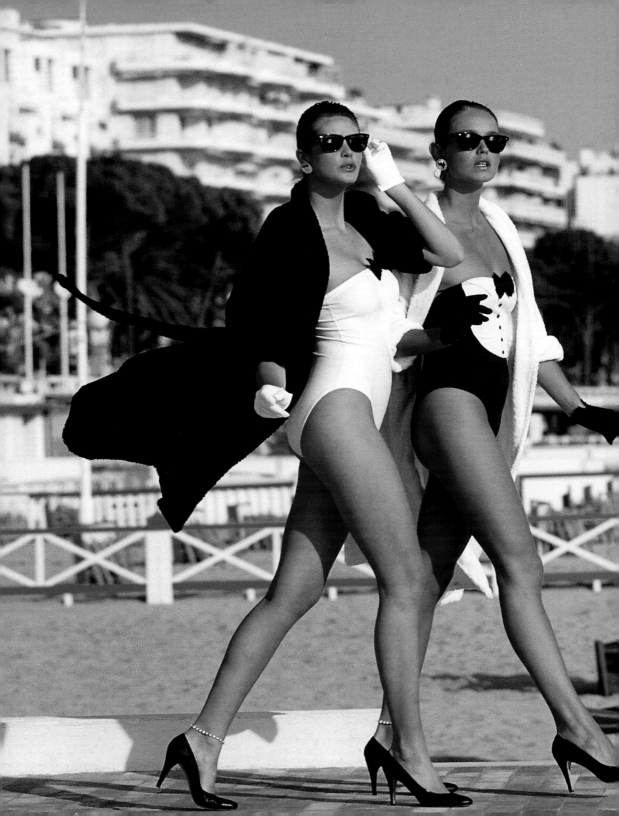

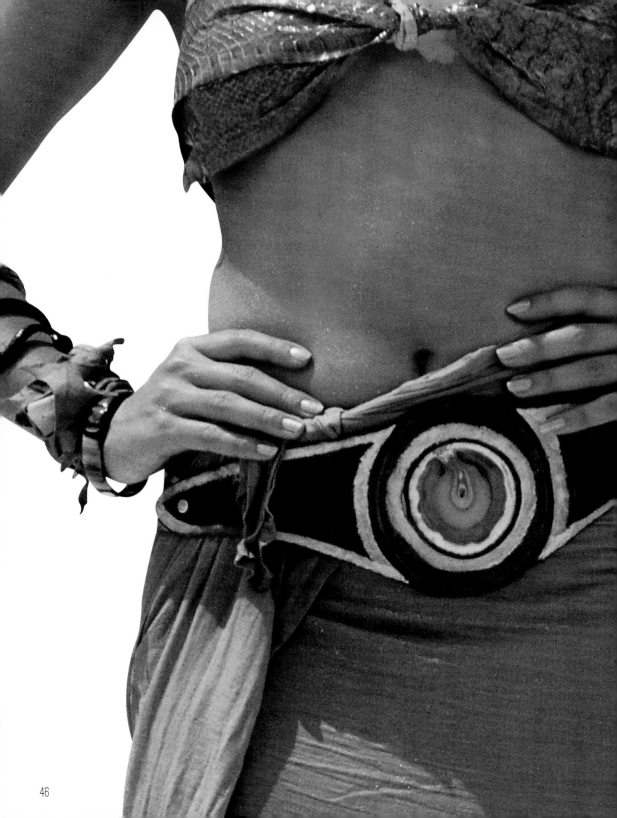

Previous pages:
When swimsuits cause a stir in the la Croisette sun. Bathrobes (Le Bon Marché), pumps and rhinestone ankle bracelets (Yves Saint Laurent).
Left: Wide agate-encrusted belt, rawhide bracelets and straw bangles, various snake and lucky charm bracelets in summer colors.

Next pages:
Left: Photographer starlet in cotton jersey dress with lace panels (Alain Manoukian). Silver-threaded, crushed cotton voile petticoat (Marciej Zych for Takara).
Right: Ribbed cotton jersey tank-top dress and matching cardigan tied around the waist (Caroline Freesa for Altona). Wraparound Mikli sunglasses.

"Ethnic and chic: an amazing twofer."

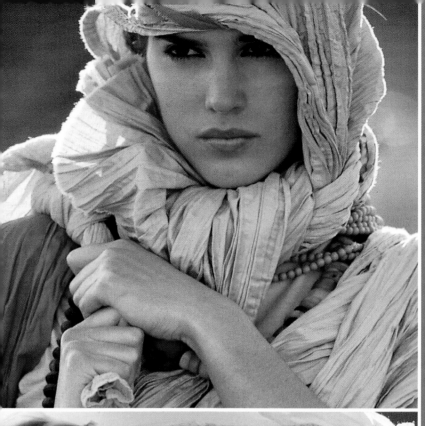

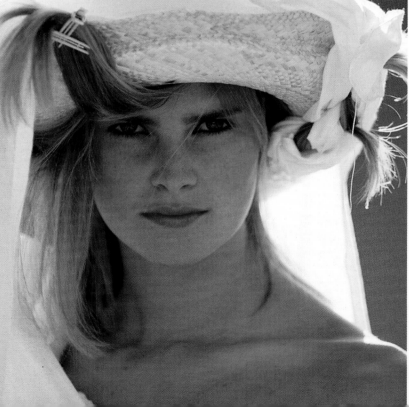

Top left: Wrap artists. The Arab headscarf as a new ethnic fashion accessory. Wood necklace (Sandy).
Bottom left: A radiant face well protected by a wide-rimmed, turbaned straw hat (World's End).
Right: Silk kimono jacket (Kenzo) worn over a short linen V-necked bodice (Apostrophe). Bracelet (Takara).

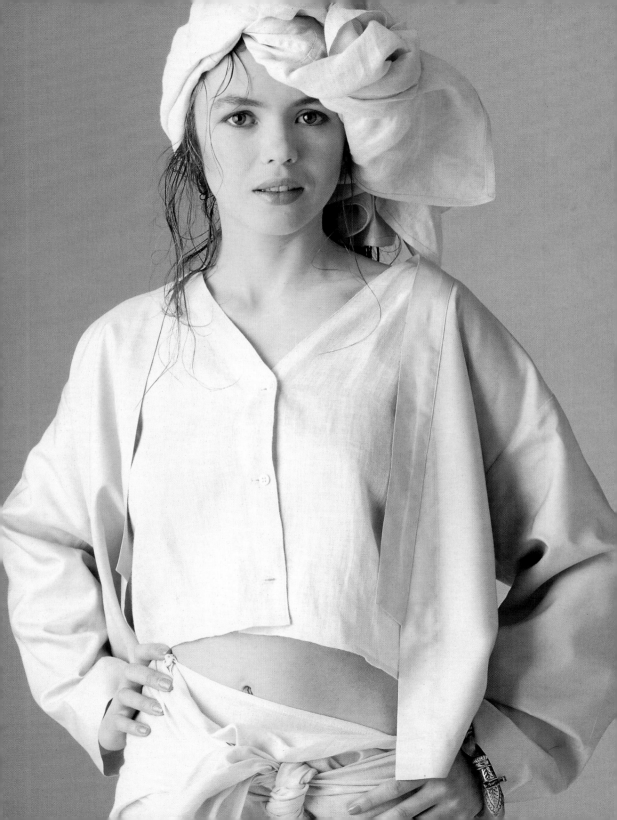

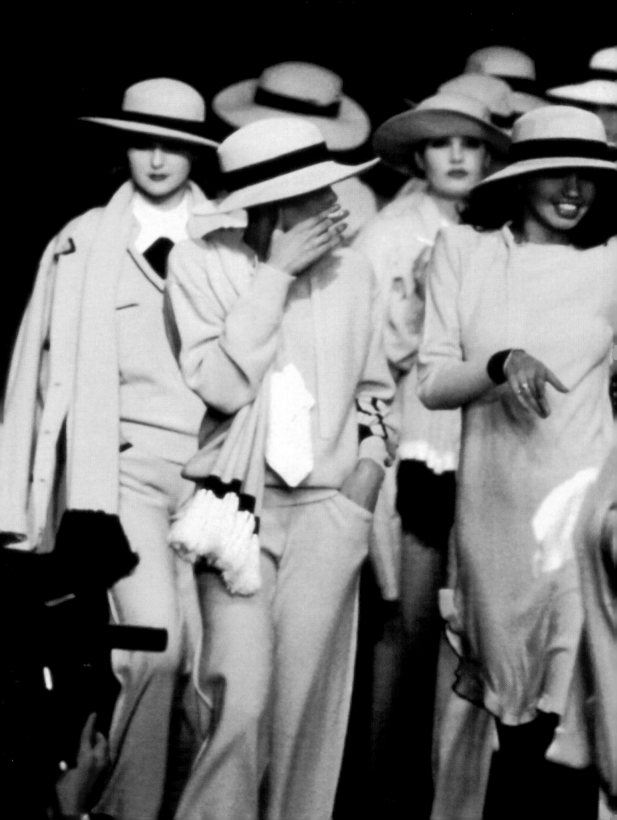

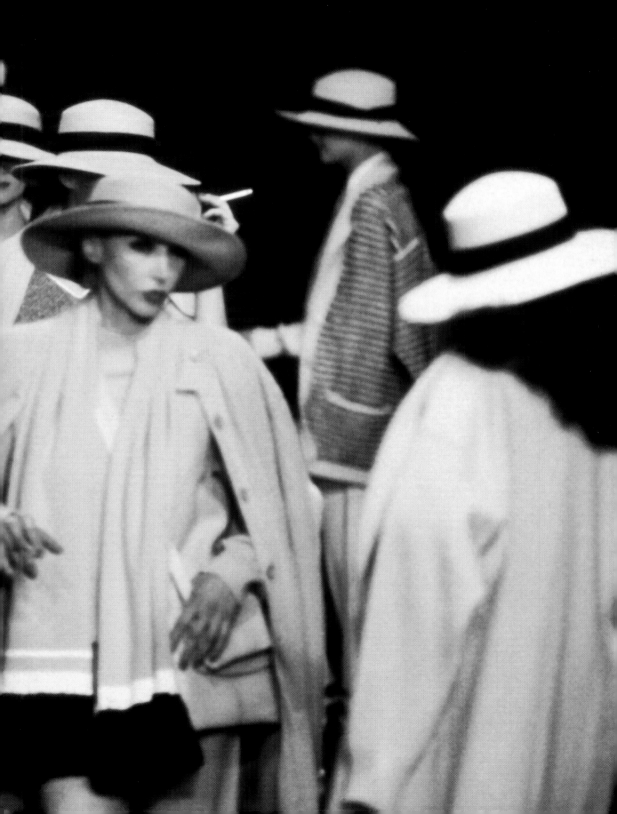

Sonia Rykiel

Previous pages:
Fashion 1981 style;
a huge mixture of genres
and looks. At the Sonia
Rykiel show the
androgenous allure
triumphs.

Right: The spirit of 1980.
Neither revolution nor
revelation, but a logical
evolution. Materials
fit trends, and Sonia Rykiel
reinvents classic knitwear.

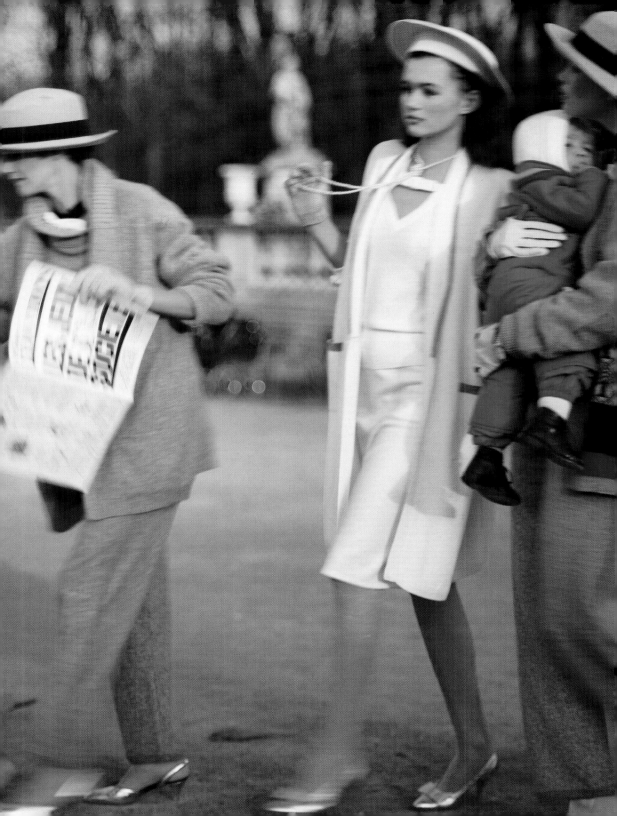

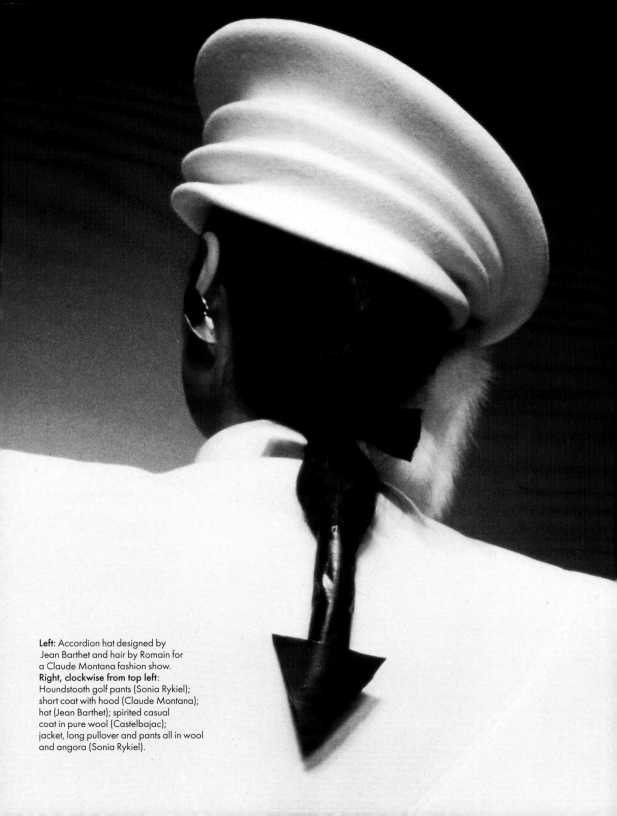

Left: Accordion hat designed by
Jean Barthet and hair by Romain for
a Claude Montana fashion show.
Right, clockwise from top left:
Houndstooth golf pants (Sonia Rykiel);
short coat with hood (Claude Montana);
hat (Jean Barthet); spirited casual
coat in pure wool (Castelbajac);
jacket, long pullover and pants all in wool
and angora (Sonia Rykiel).

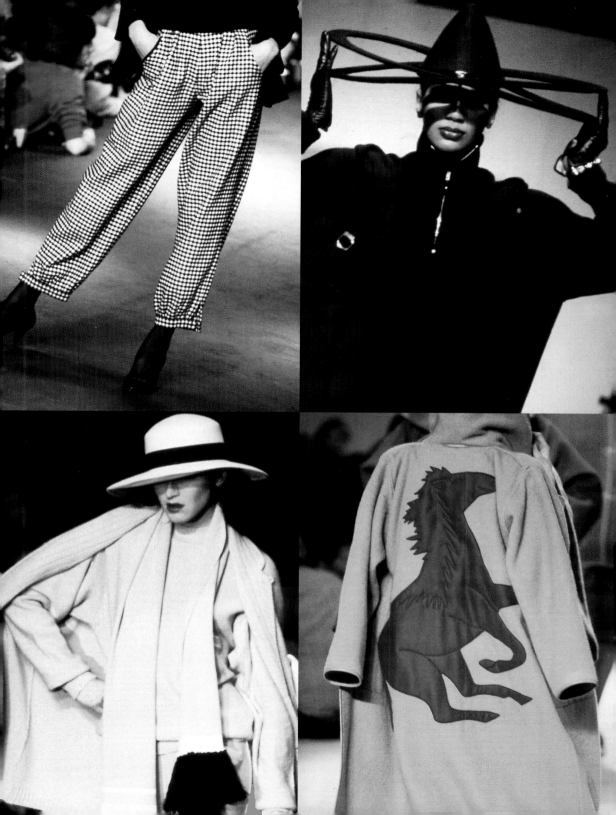

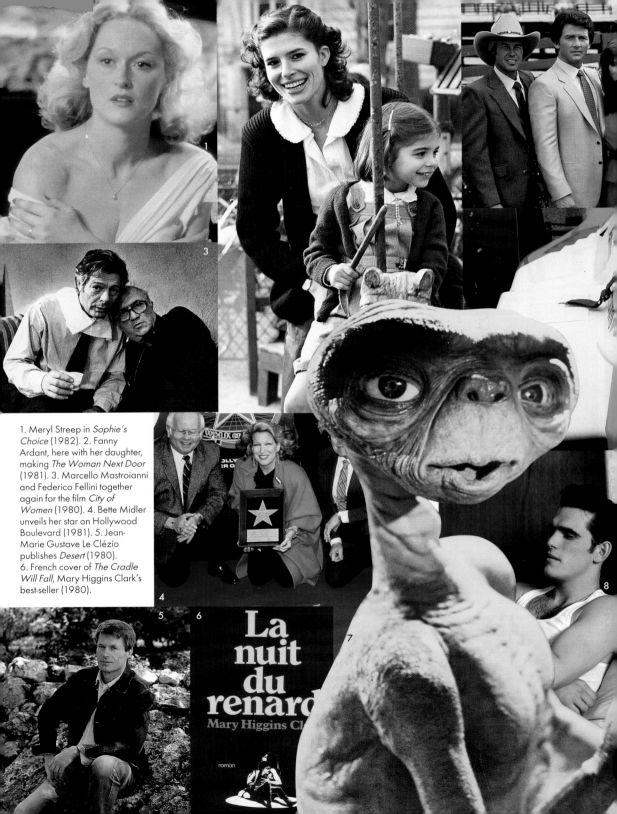

1. Meryl Streep in *Sophie's Choice* (1982). 2. Fanny Ardant, here with her daughter, making *The Woman Next Door* (1981). 3. Marcello Mastroianni and Federico Fellini together again for the film *City of Women* (1980). 4. Bette Midler unveils her star on Hollywood Boulevard (1981). 5. Jean-Marie Gustave Le Clézio publishes *Desert* (1980). 6. French cover of *The Cradle Will Fall*, Mary Higgins Clark's best-seller (1980).

La nuit du renard

Mary Higgins Clark

roman

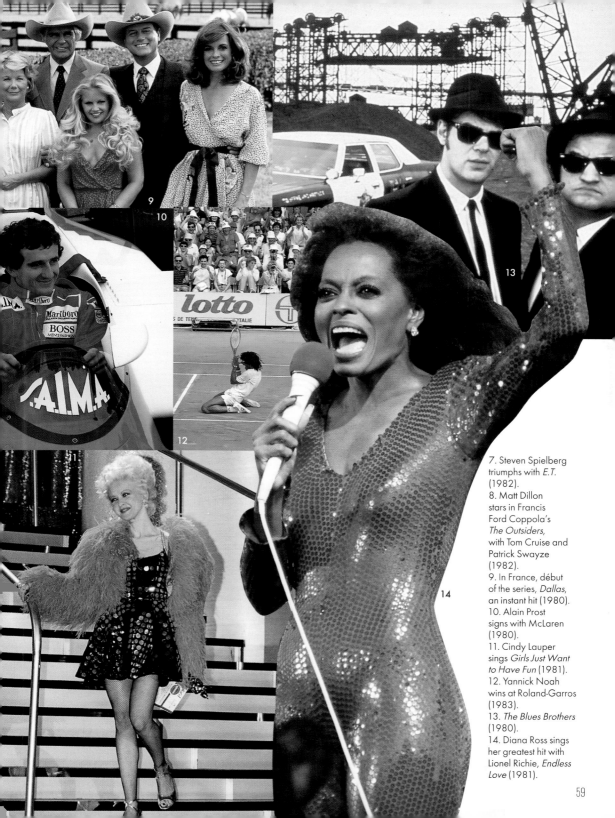

7. Steven Spielberg triumphs with *E.T.* (1982).

8. Matt Dillon stars in Francis Ford Coppola's *The Outsiders*, with Tom Cruise and Patrick Swayze (1982).

9. In France, début of the series, *Dallas*, an instant hit (1980).

10. Alain Prost signs with McLaren (1980).

11. Cindy Lauper sings *Girls Just Want to Have Fun* (1981).

12. Yannick Noah wins at Roland-Garros (1983).

13. *The Blues Brothers* (1980).

14. Diana Ross sings her greatest hit with Lionel Richie, *Endless Love* (1981).

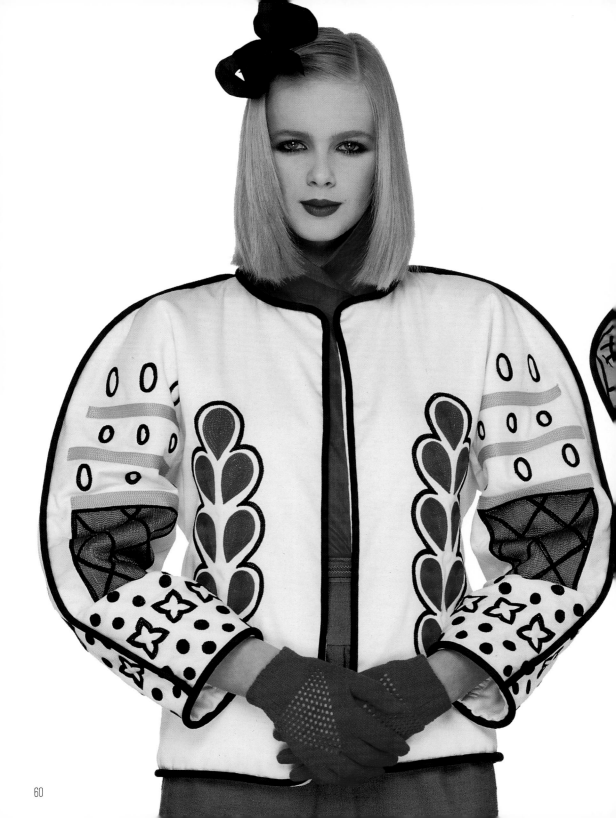

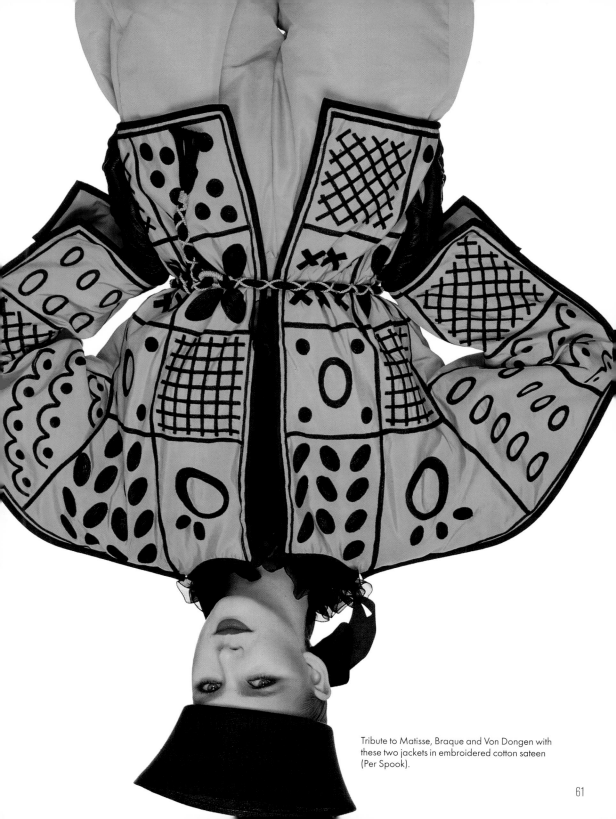

Tribute to Matisse, Braque and Von Dongen with these two jackets in embroidered cotton sateen (Per Spook).

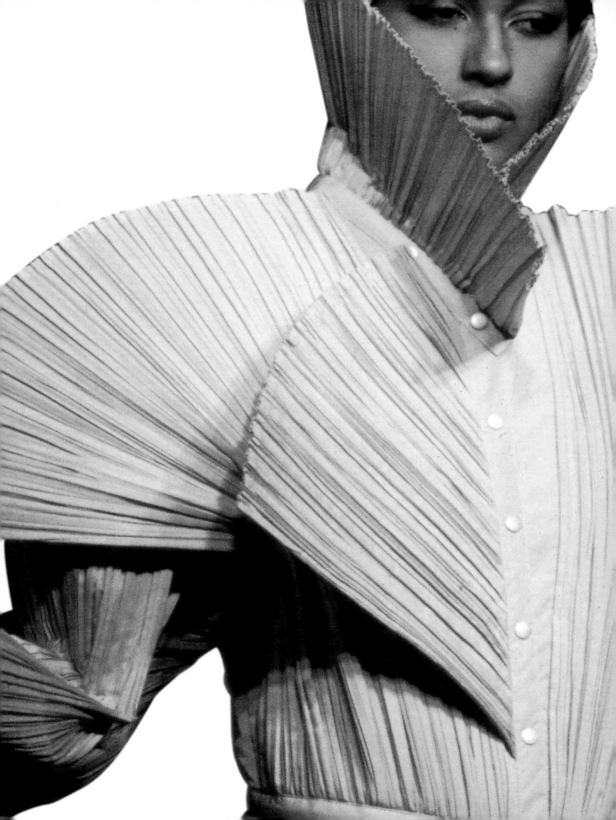

Issey Miyaké

Left: East meets West with this fan-shaped jacket designed by the master of pleats, Issey Miyaké. Makeup Shiseido.

Following pages, left: Fanciful cape and skirt in gold organza, over glittery ballet-style stretch bodystocking (Popy Moreni). **Right:** Gold leather sheath dress, laced from behind (Thierry Mugler).

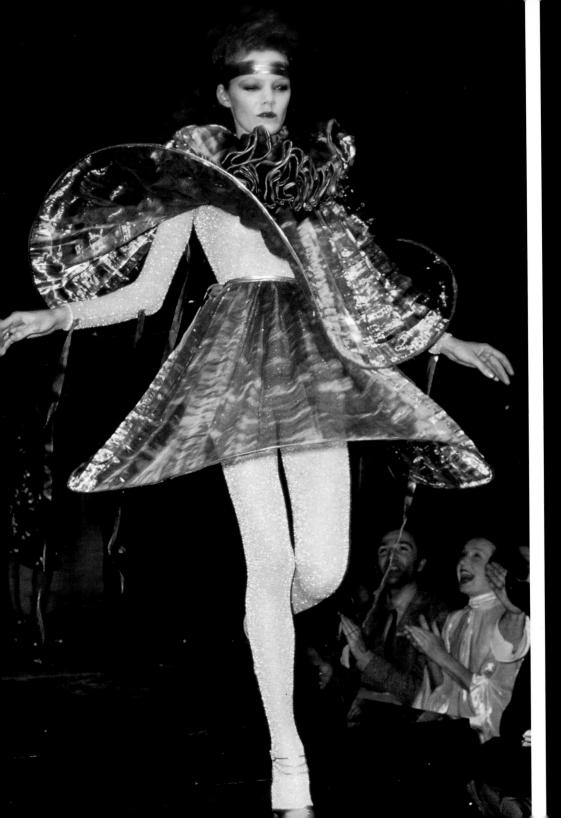

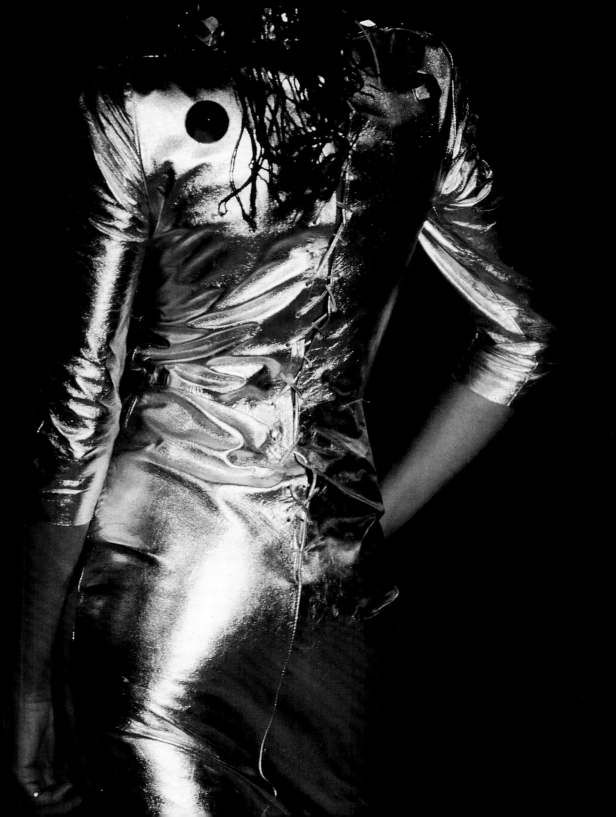

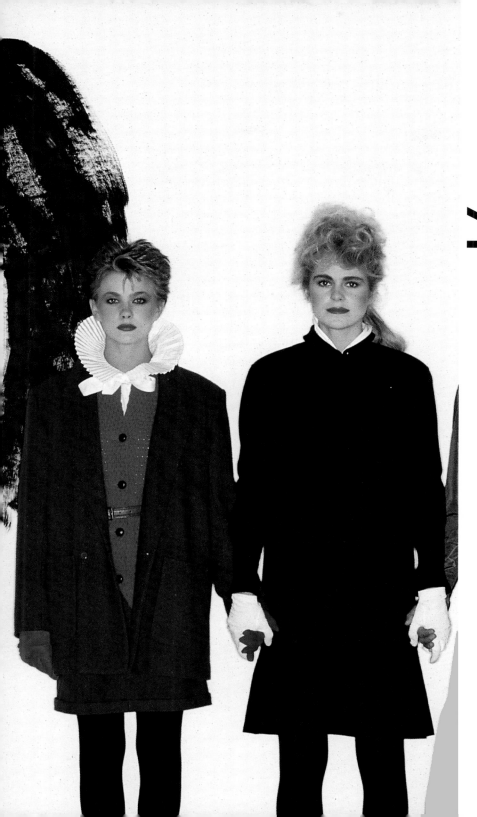

Kenzo

For Kenzo, everything starts with a drawing. Dynamic and romantic, the most Parisian of Japanese designers presents his summer 1982 collection.

1984 ▶ Apple's Macintosh computer is introduced, February 8. **Carl Lewis** wins four gold medals at Los Angeles Olympic Games. Death of French film director **François Truffaut**, October 21. The cause of **AIDS** is isolated and the **virus** is named **Human Immunodeficiency Virus** (HIV). At the **movies**: Francis Ford Coppola's **The Cotton Club**, Milos Forman's **Amadeus**, and Wim Wenders's **Paris-Texas**. Assassination of **Indira Gandhi**, October 31. President **Ronald Reagan** is reelected in landslide with **59%** of vote. **The Cosby Show** debuts on NBC.

1985 ▶ 40 artists record **"We are the World,"** a hit song composed by Michael Jackson and Lionel Richie that eventually raises **$50 million** for famine relief in Africa. Soviet leader **Konstantin Chernenko** dies on March 11, and **Mikhail Gorbachev** takes over. Robert Zemeckis's **Back to the Future** triumphs on the big screen, as well as George P. Cosmatos's **Rambo: First Blood Part II**. Treaty with Great Britain gives **Ireland** role in Northern Ireland. U.S. Congress enacts the **Balanced Budget** and Emergency Deficit Control Act. **British scientists** report opening of a huge hole in the earth's **Ozone** layer. U.S. **Grammy Record** of the Year: **What's Love Got to do With It**, by Tina Turner.

1986 ▶ Space shuttle **Challenger** explodes 30 seconds after liftoff, killing all seven aboard, January 28. **Spain** and **Portugal** join European Economic Community. Death of the **Duchess of Windsor**, April 24. **Diego Maradona** offers **Argentina** his second soccer World Cup. **Chernobyl** nuclear disaster, April 26. Steven King's **It** is a best-seller. **Nintendo video games** are introduced in the U.S. First **non-stop flight** around the world without refueling, December 23.

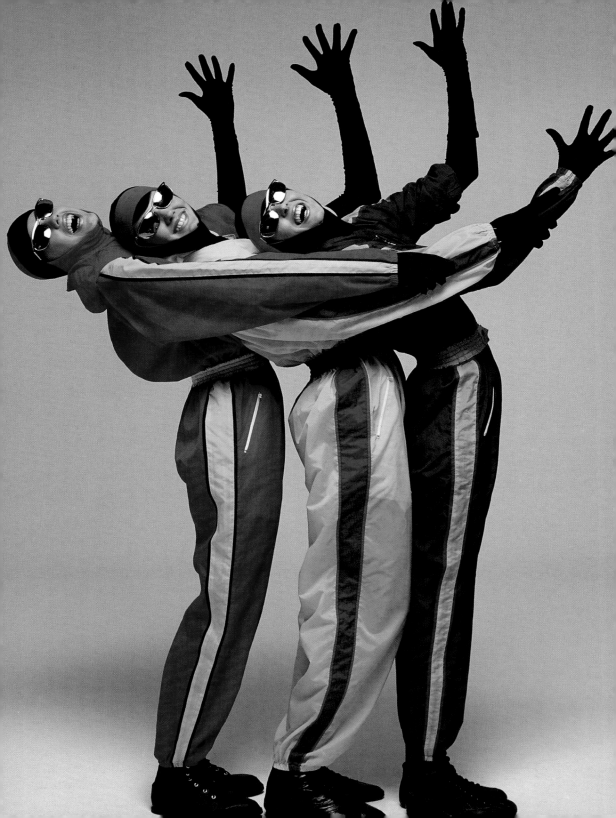

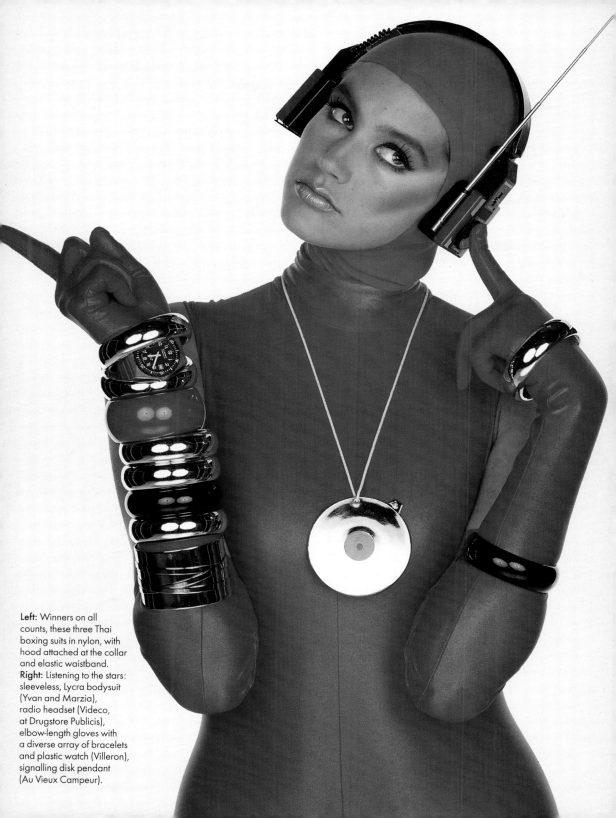

Left: Winners on all counts, these three Thai boxing suits in nylon, with hood attached at the collar and elastic waistband.
Right: Listening to the stars: sleeveless, Lycra bodysuit (Yvan and Marzia), radio headset (Videco, at Drugstore Publicis), elbow-length gloves with a diverse array of bracelets and plastic watch (Villeron), signalling disk pendant (Au Vieux Campeur).

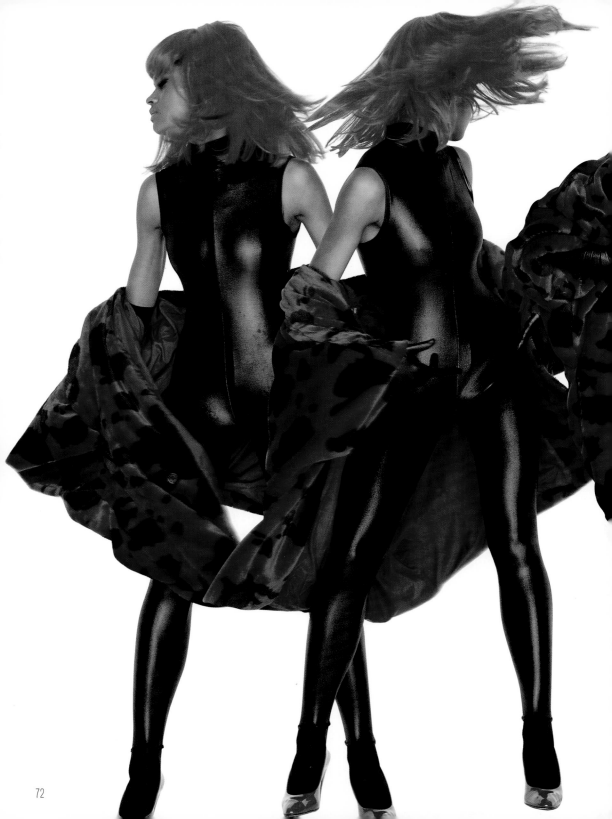

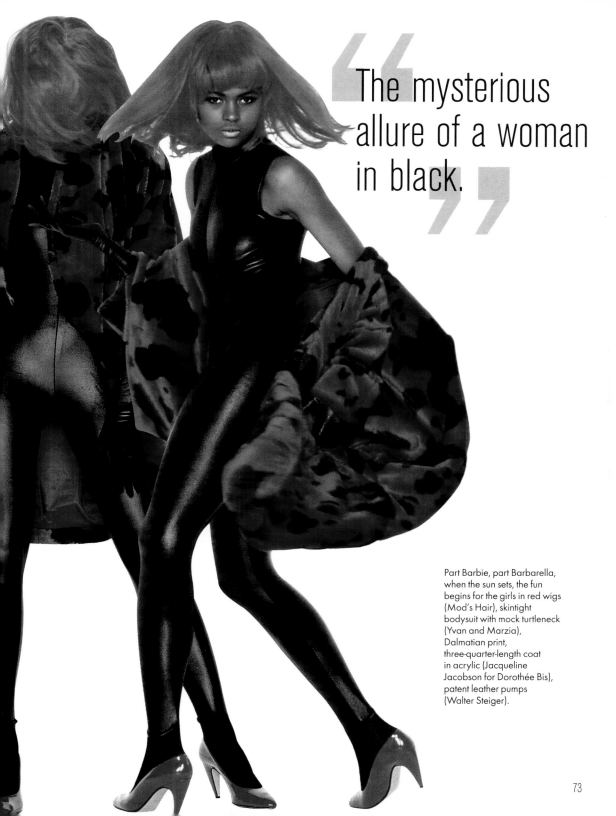

"The mysterious allure of a woman in black."

Part Barbie, part Barbarella, when the sun sets, the fun begins for the girls in red wigs (Mod's Hair), skintight bodysuit with mock turtleneck (Yvan and Marzia), Dalmatian print, three-quarter-length coat in acrylic (Jacqueline Jacobson for Dorothée Bis), patent leather pumps (Walter Steiger).

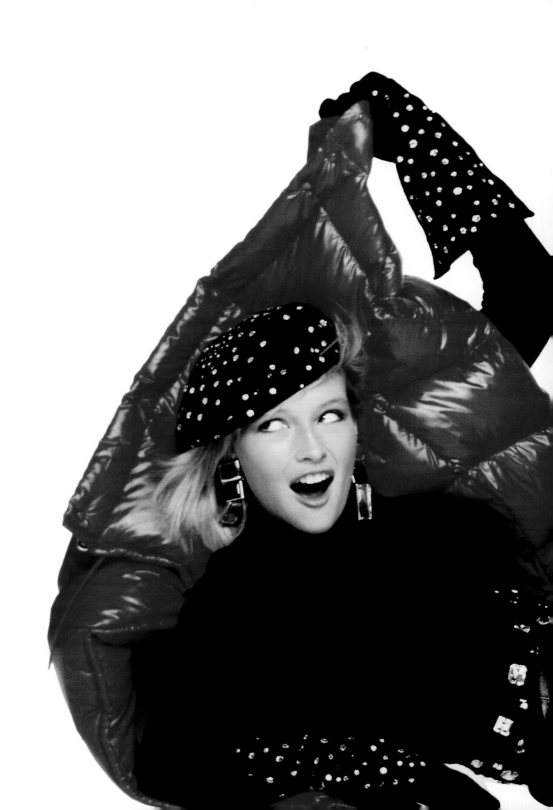

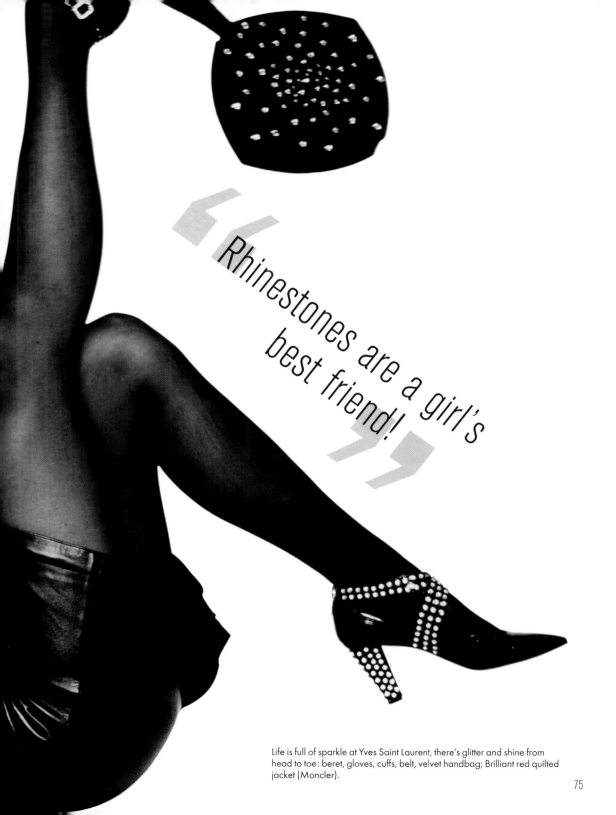

" Rhinestones are a girl's best friend! "

Life is full of sparkle at Yves Saint Laurent, there's glitter and shine from head to toe: beret, gloves, cuffs, belt, velvet handbag; Brilliant red quilted jacket (Moncler).

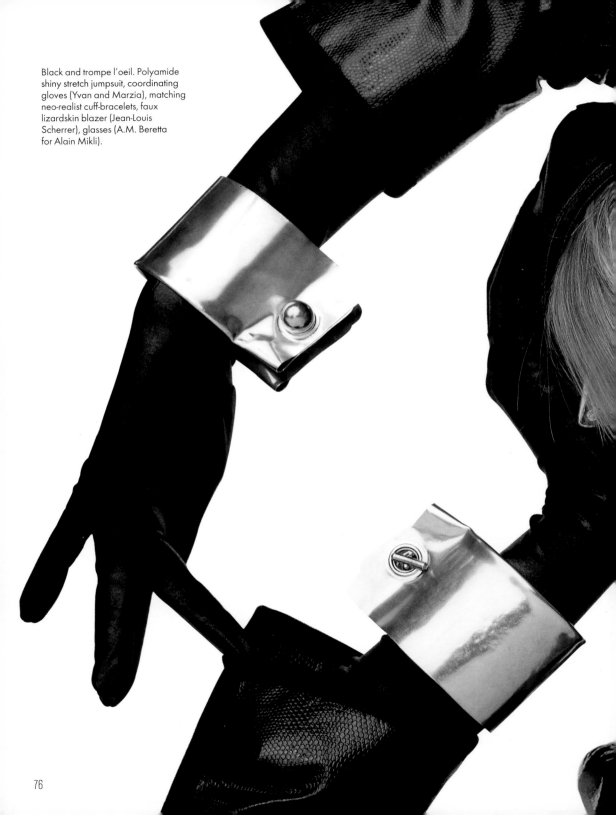

Black and trompe l'oeil. Polyamide shiny stretch jumpsuit, coordinating gloves (Yvan and Marzia), matching neo-realist cuff-bracelets, faux lizardskin blazer (Jean-Louis Scherrer), glasses (A.M. Beretta for Alain Mikli).

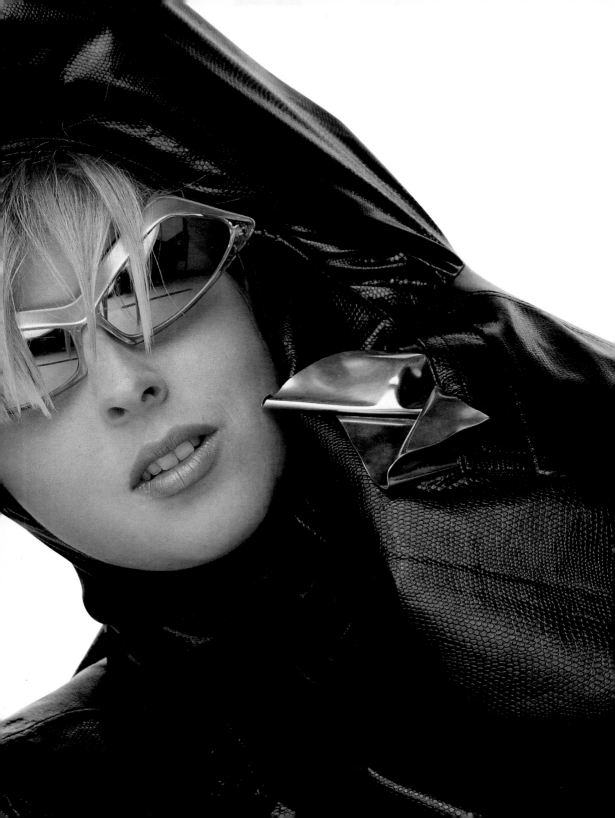

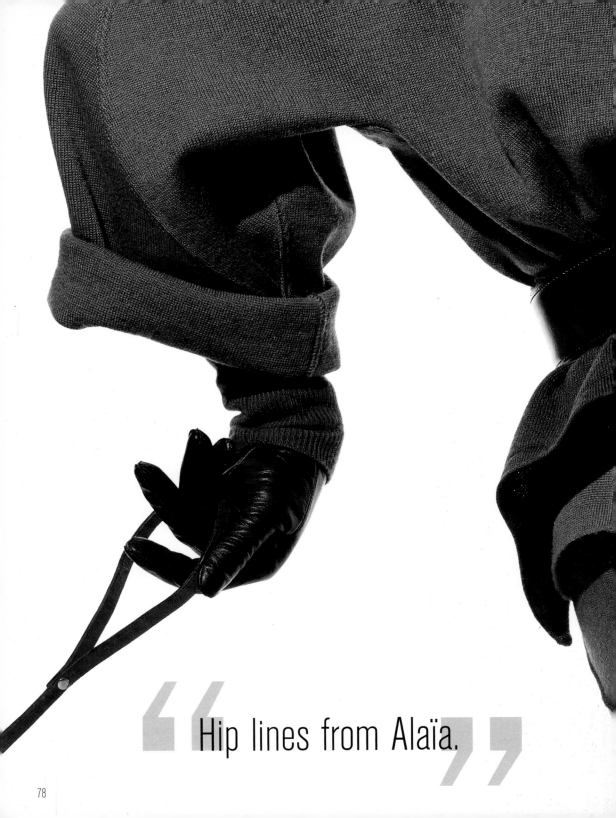

"Hip lines from Alaïa."

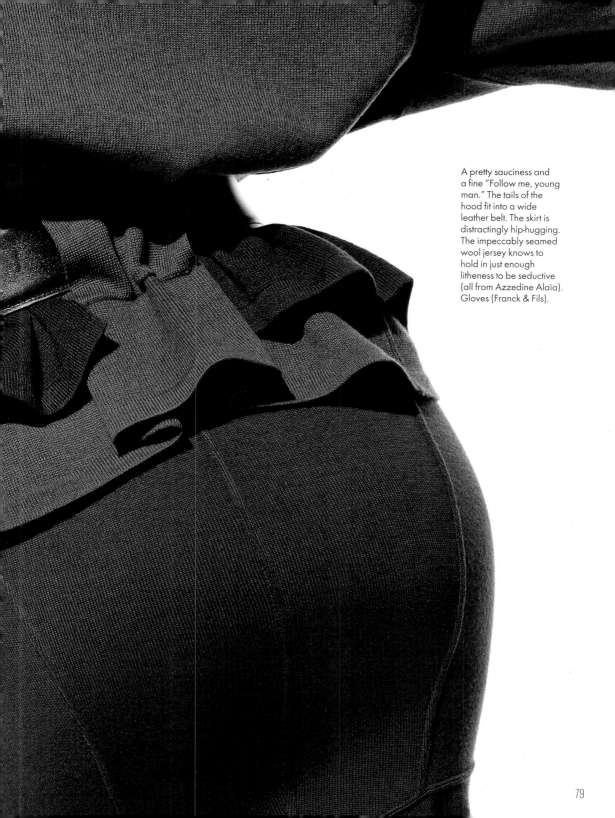

A pretty sauciness and
a fine "Follow me, young
man." The tails of the
hood fit into a wide
leather belt. The skirt is
distractingly hip-hugging.
The impeccably seamed
wool jersey knows to
hold in just enough
litheness to be seductive
(all from Azzedine Alaïa).
Gloves (Franck & Fils).

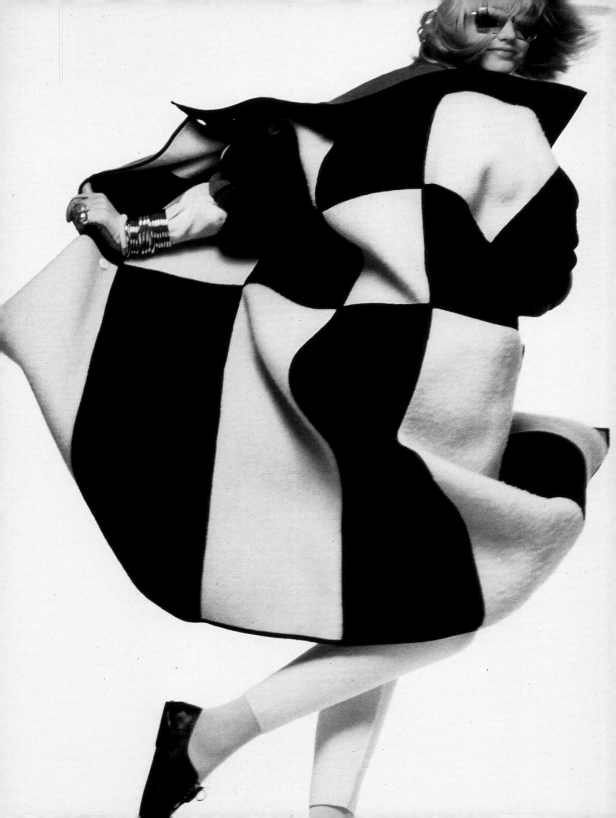

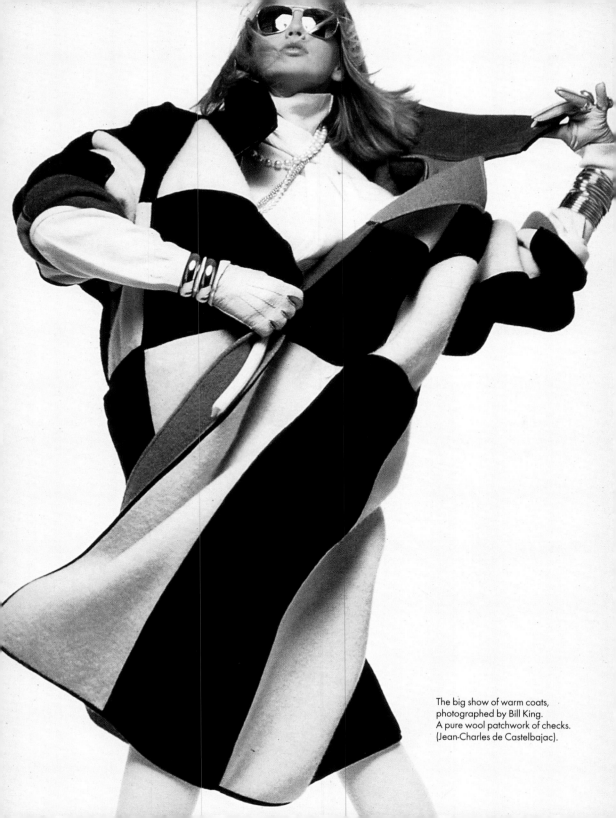

The big show of warm coats,
photographed by Bill King.
A pure wool patchwork of checks.
(Jean-Charles de Castelbajac).

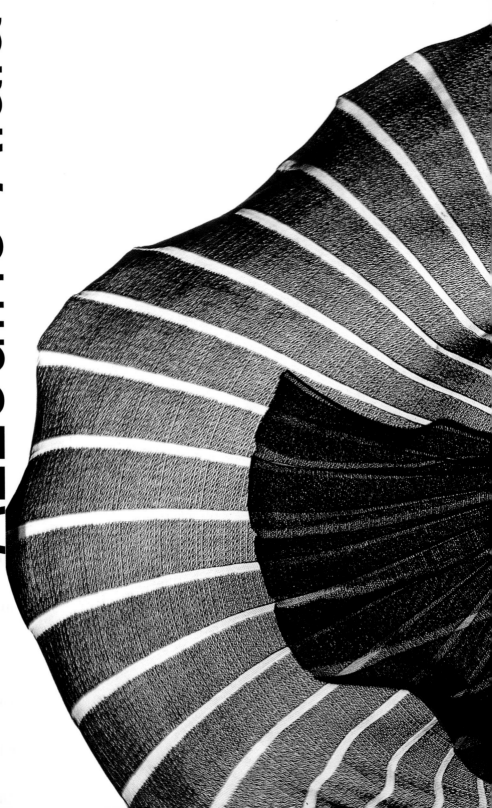

Azzedine Alaïa

The little big man of the new wave in fashion design. He likes bold statements, thus this acetate and wool wide-stripe skirt with sunray pleats.
Alaïa is as comfortable with the traditional techniques of the great Parisian design studios as he is with the new high-tech materials.

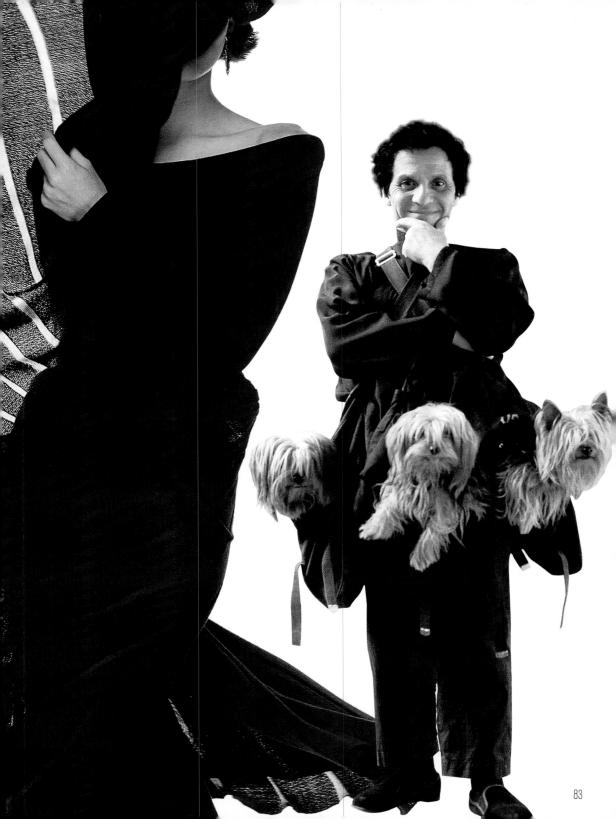

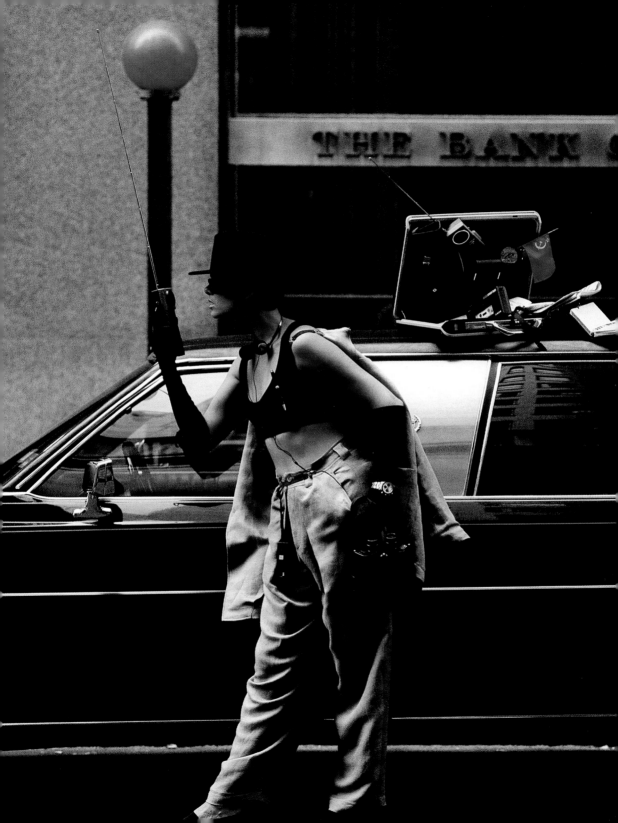

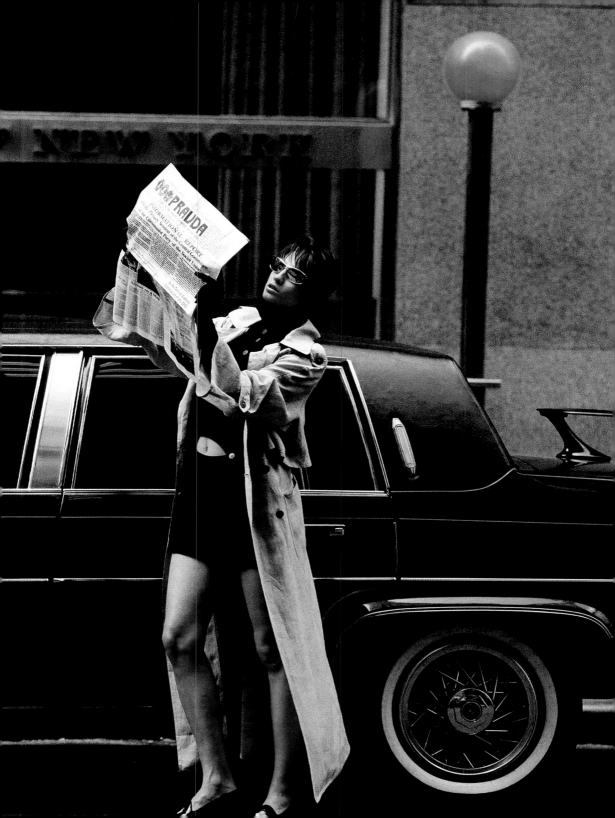

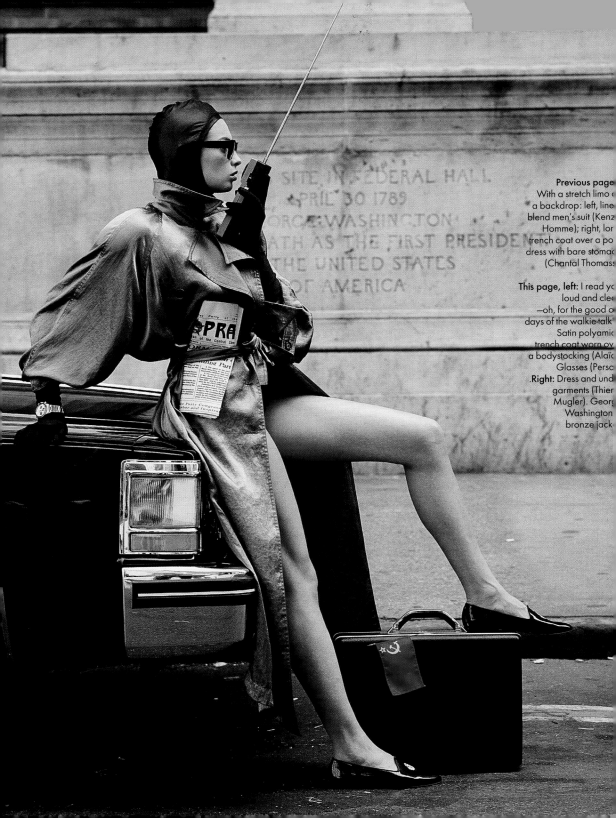

SITE, IN FEDERAL HALL
PRIL 30 1789
ORGE WASHINGTON
ATH AS THE FIRST PRESIDENT
THE UNITED STATES
OF AMERICA

Previous page
With a stretch limo
a backdrop: left, line
blend men's suit (Kenz
Homme); right, lor
trench coat over a po
dress with bare stomac
(Chantal Thomass

This page, left: I read yo
loud and clee
—oh, for the good o
days of the walkie-talk
Satin polyamic
trench coat worn ov
a bodystocking (Alaïa
Glasses (Perso
Right: Dress and und
garments (Thier
Mugler). Georg
Washington
bronze jack

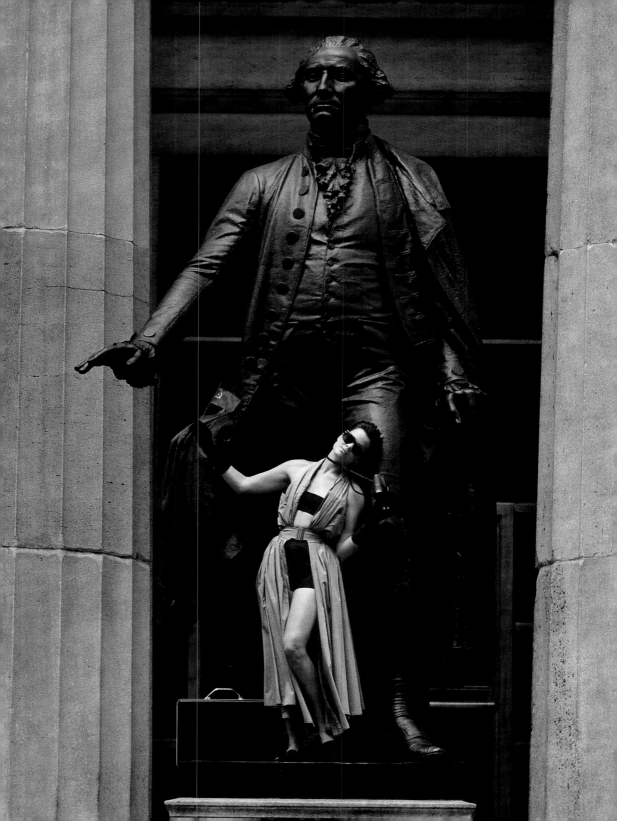

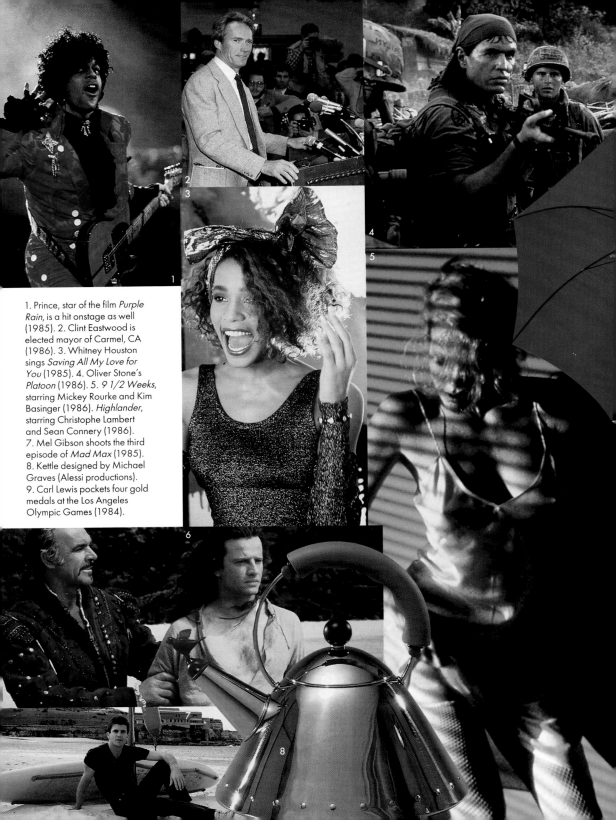

1. Prince, star of the film *Purple Rain*, is a hit onstage as well (1985). 2. Clint Eastwood is elected mayor of Carmel, CA (1986). 3. Whitney Houston sings *Saving All My Love for You* (1985). 4. Oliver Stone's *Platoon* (1986). 5. *9 1/2 Weeks*, starring Mickey Rourke and Kim Basinger (1986). *Highlander*, starring Christophe Lambert and Sean Connery (1986). 7. Mel Gibson shoots the third episode of *Mad Max* (1985). 8. Kettle designed by Michael Graves (Alessi productions). 9. Carl Lewis pockets four gold medals at the Los Angeles Olympic Games (1984).

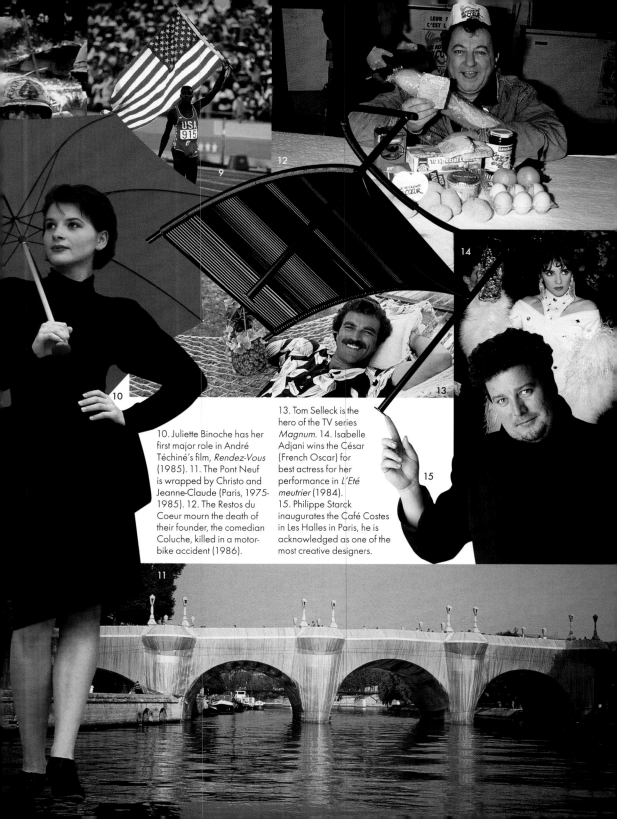

9

12

14

10

13

10. Juliette Binoche has her first major role in André Téchiné's film, *Rendez-Vous* (1985). 11. The Pont Neuf is wrapped by Christo and Jeanne-Claude (Paris, 1975-1985). 12. The Restos du Coeur mourn the death of their founder, the comedian Coluche, killed in a motor-bike accident (1986).

13. Tom Selleck is the hero of the TV series *Magnum*. 14. Isabelle Adjani wins the César (French Oscar) for best actress for her performance in *L'Eté meutrier* (1984).
15. Philippe Starck inaugurates the Café Costes in Les Halles in Paris, he is acknowledged as one of the most creative designers.

15

11

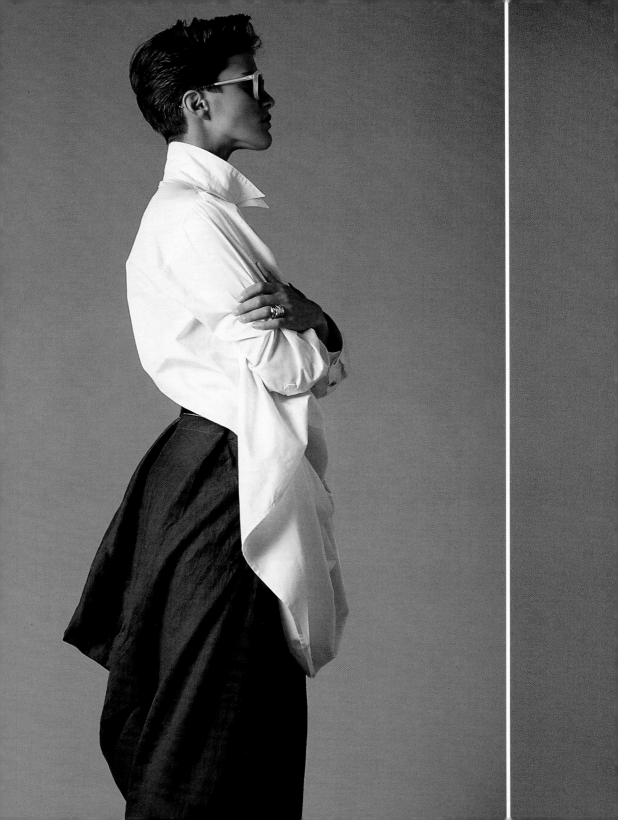

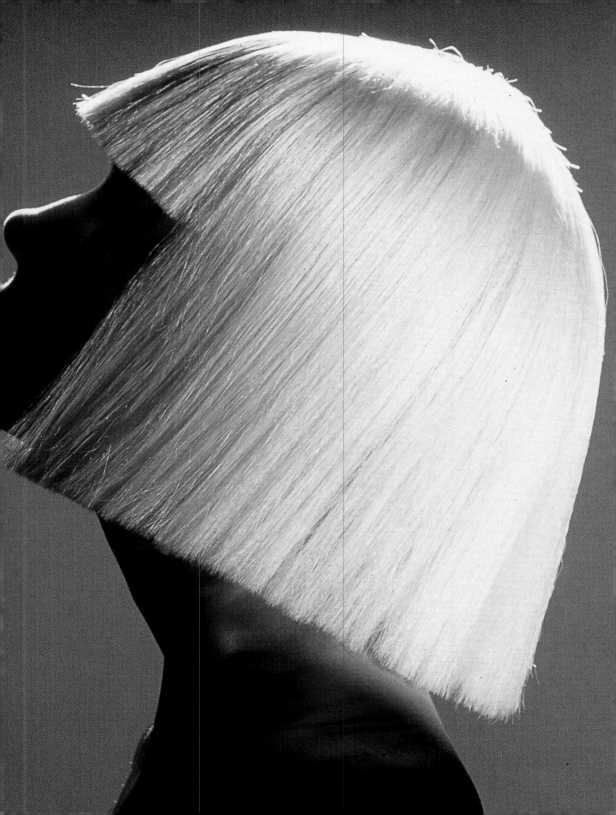

"When fashion and disco danced together."

Previous pages, left:
Yohji Yamamoto asserts
his mastery with this
poplin open-back dinner
shirt worn over a wide
flared linen skirt.
Glasses (Mikli).
Right: The inevitable
comeback of the blonde,
more platinum than
ever in Chantal
Thomass's 1985 version.

Opposite: Full bull's-eye
skirt in mixed cotton
poplin (Jean-Rémy
Daumas). Lycra jumpsuit
(Repetto).

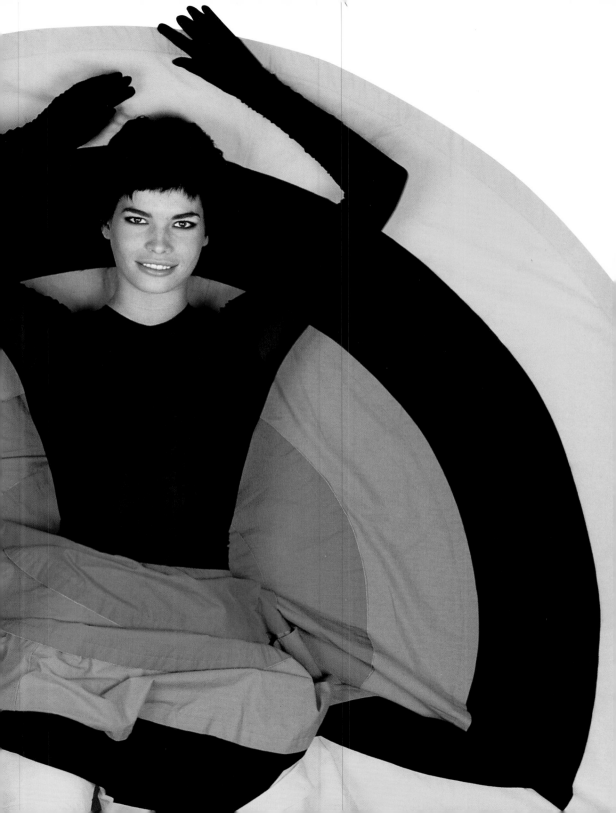

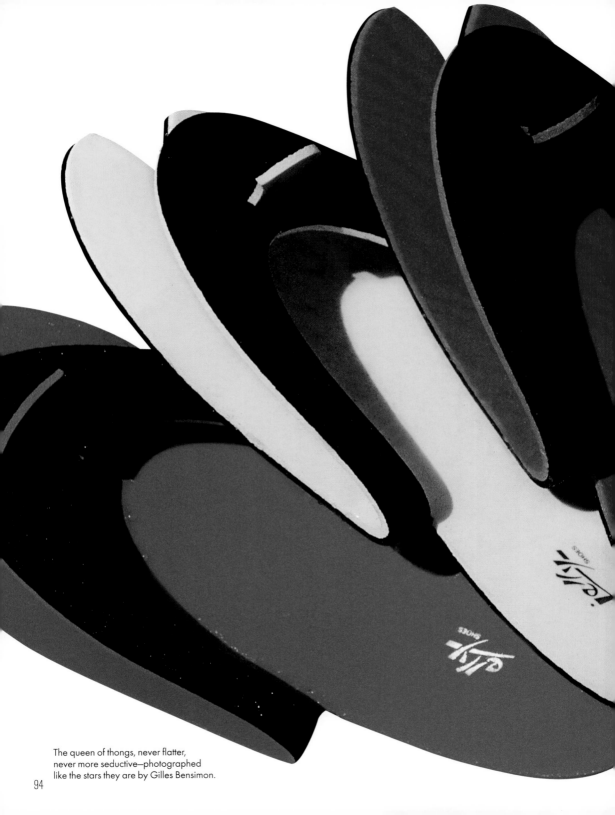

The queen of thongs, never flatter,
never more seductive—photographed
like the stars they are by Gilles Bensimon.

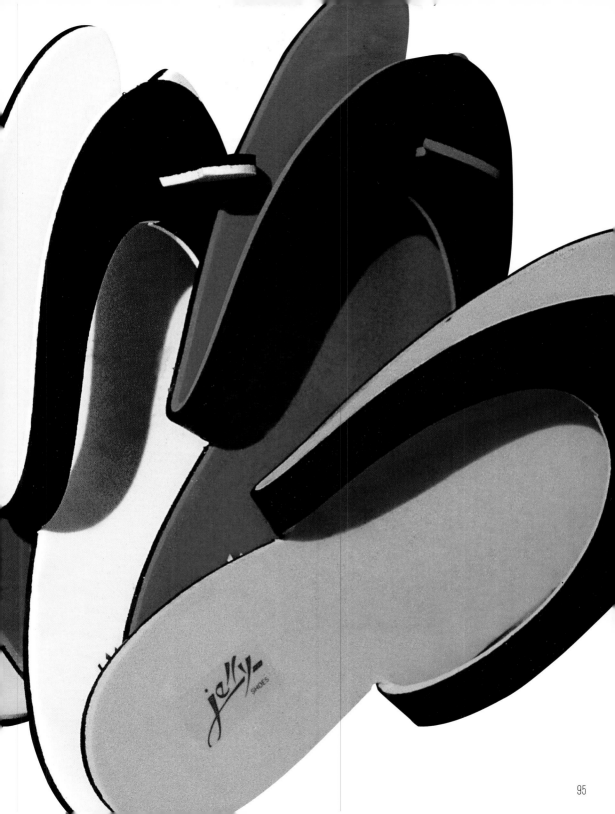

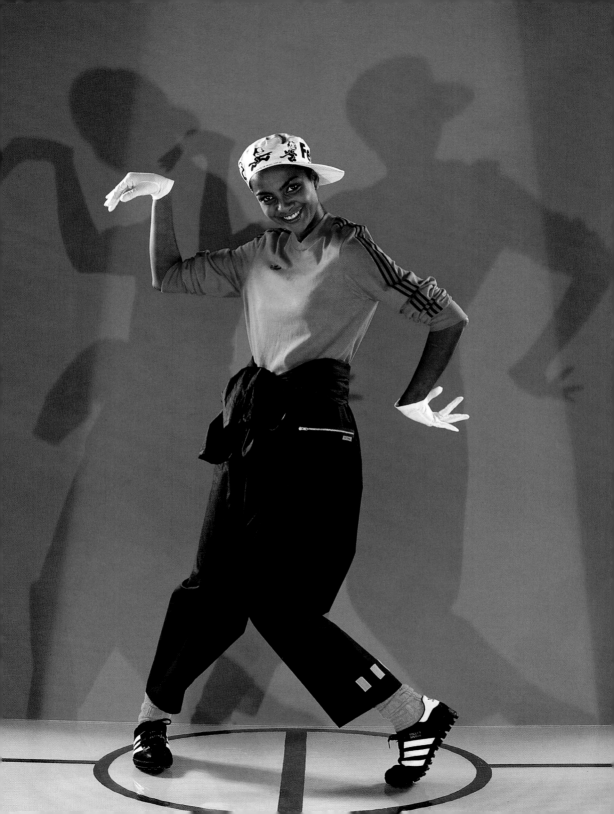

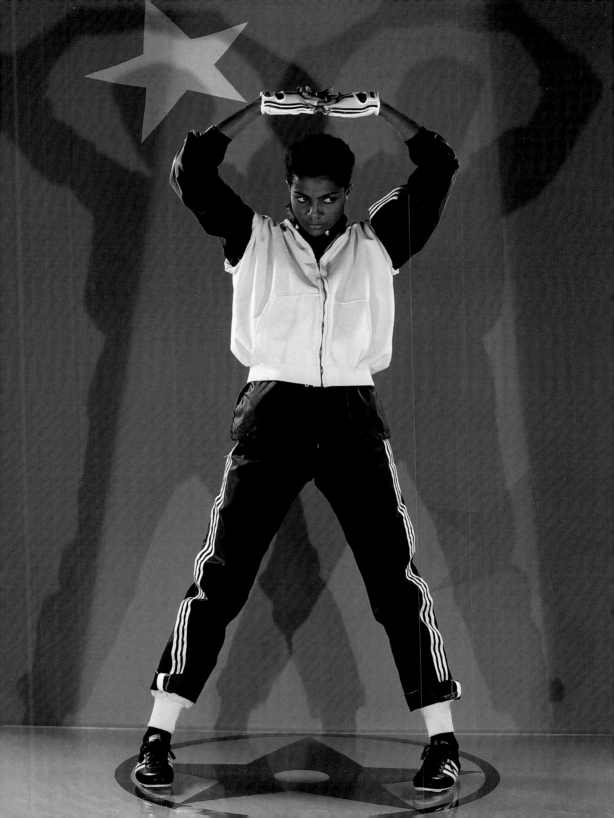

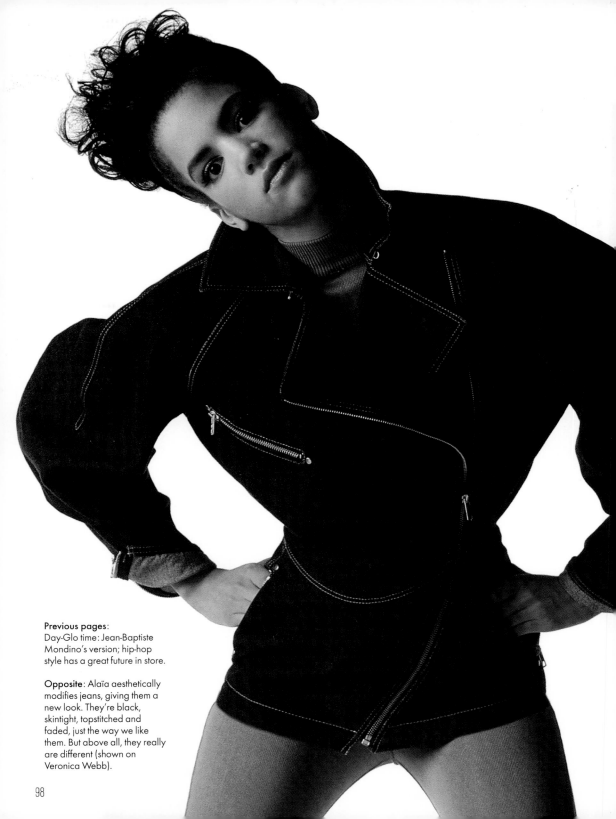

Previous pages:
Day-Glo time: Jean-Baptiste Mondino's version; hip-hop style has a great future in store.

Opposite: Alaïa aesthetically modifies jeans, giving them a new look. They're black, skintight, topstitched and faded, just the way we like them. But above all, they really are different (shown on Veronica Webb).

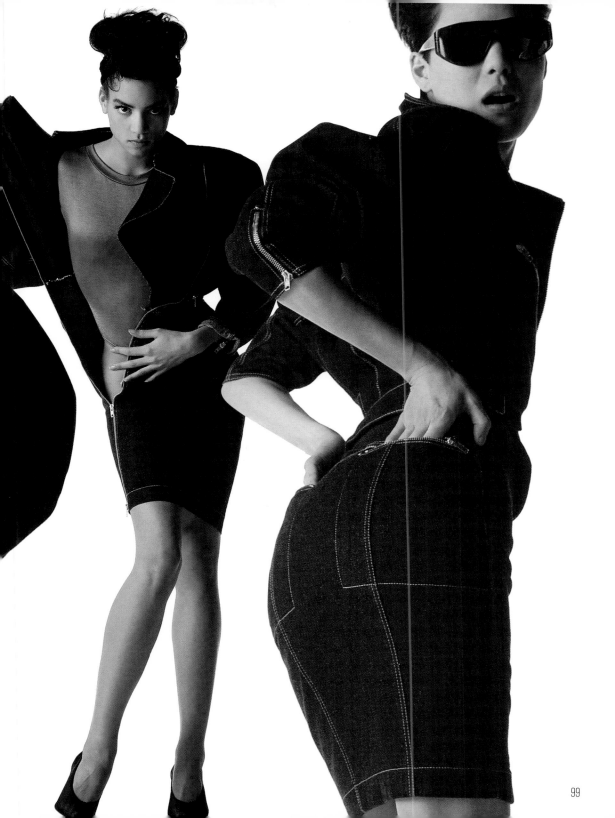

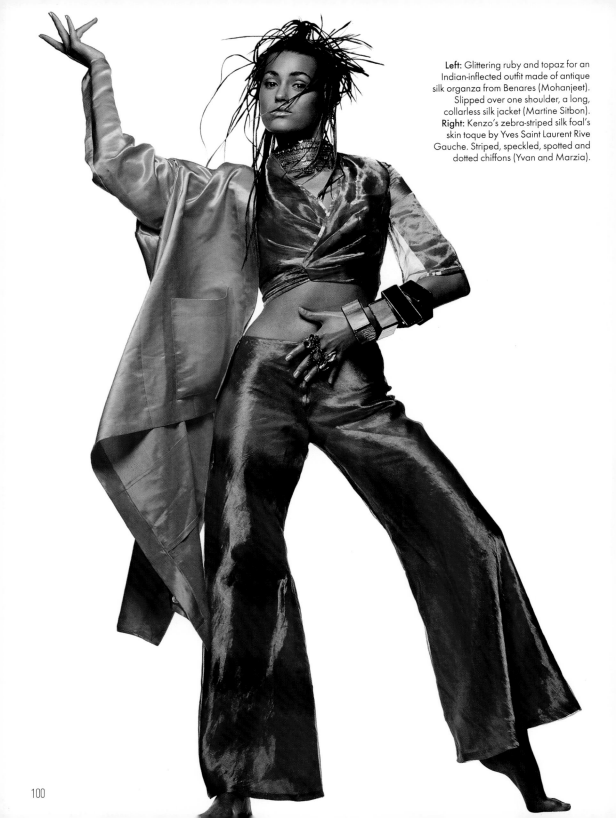

Left: Glittering ruby and topaz for an Indian-inflected outfit made of antique silk organza from Benares (Mohanjeet). Slipped over one shoulder, a long, collarless silk jacket (Martine Sitbon).
Right: Kenzo's zebra-striped silk foal's skin toque by Yves Saint Laurent Rive Gauche. Striped, speckled, spotted and dotted chiffons (Yvan and Marzia).

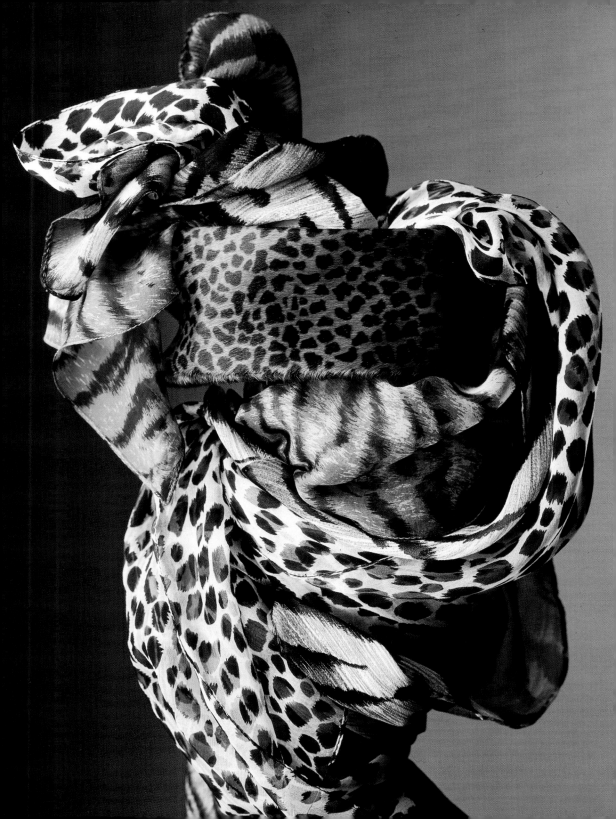

Falling
heels over head
for festive knits.

"

Close to the body and devilishly sexy:
sequined stirrup pants (Yvan and Marzia).
Long-sleeved, open-shoulder turtleneck
(Alain Derda pattern), easy to knit yourself
using Place Vendôme de Pingouin quality
wool (60% viscose, 40% polyester). Sequined
beret (Tarlazzi), glasses Claude Montana for Mikli.

Following pages: Depending on the material,
gloves can undergo a complete change of
style, becoming the essential finishing touch of
come-hither elegance. Long ribbed wool jersey
glove (Didier Renard), two-tone glove with leather
hand (Jean-Rémy Daumas), interlock glove
(Chantal Thomass), elbow-length glove in jersey
(Tarlazzi). Faux diamond necklace (Stern).

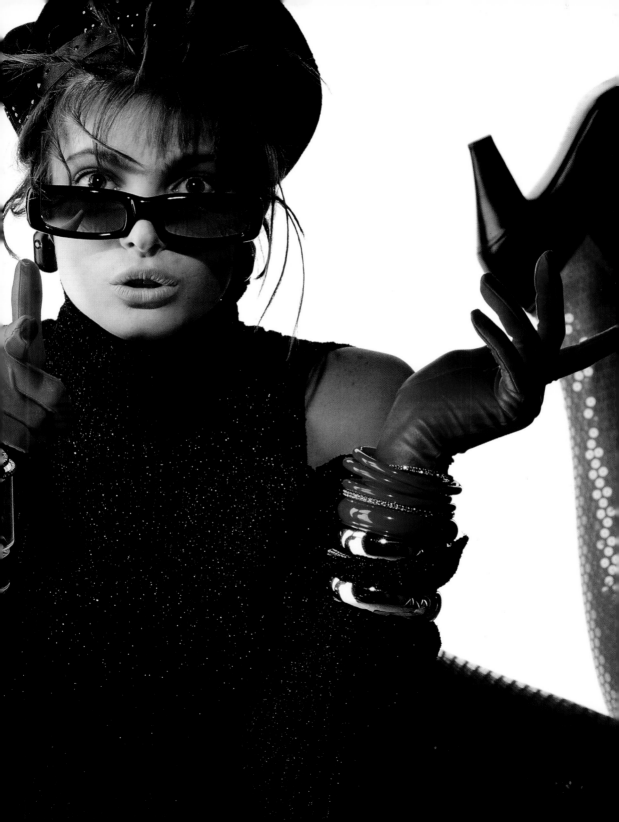

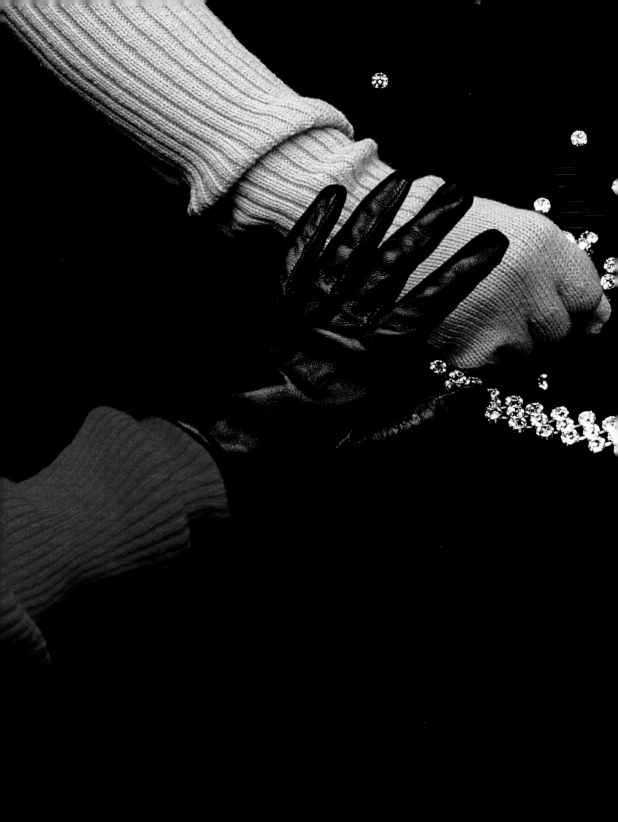

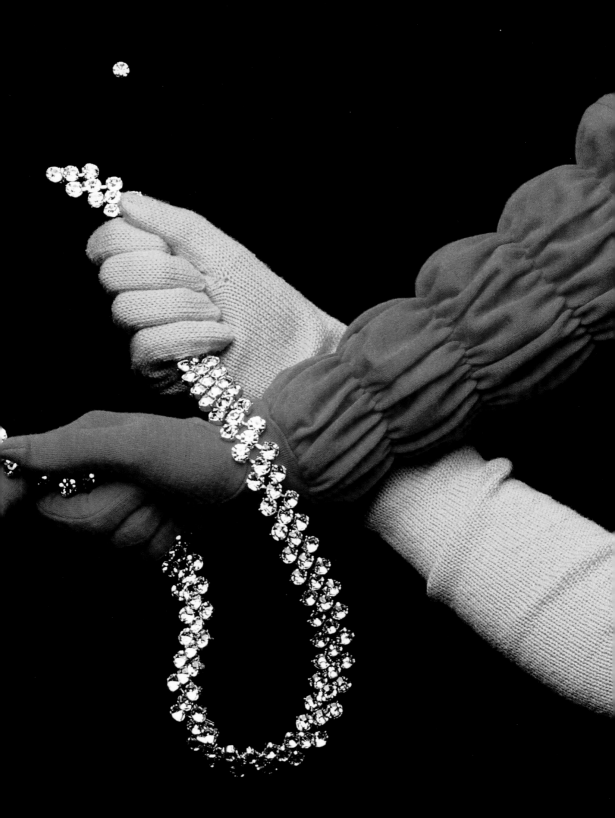

Karl Lagerfeld

A man of many talents, Lagerfeld has been a trendsetter for the past 20 years. On this page viscose polo and short-sleeved cardigan, silk chiffon skirt and straw top hat (all by Karl Lagerfeld).

106

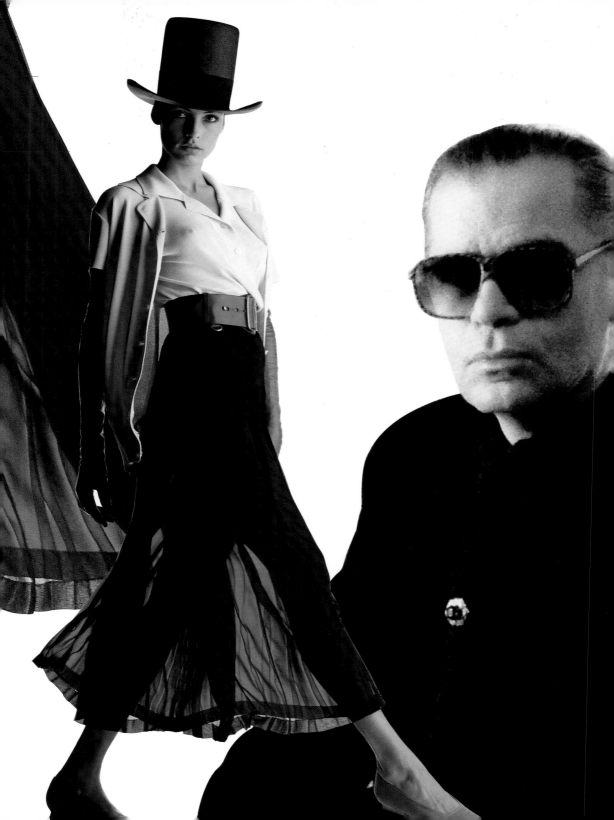

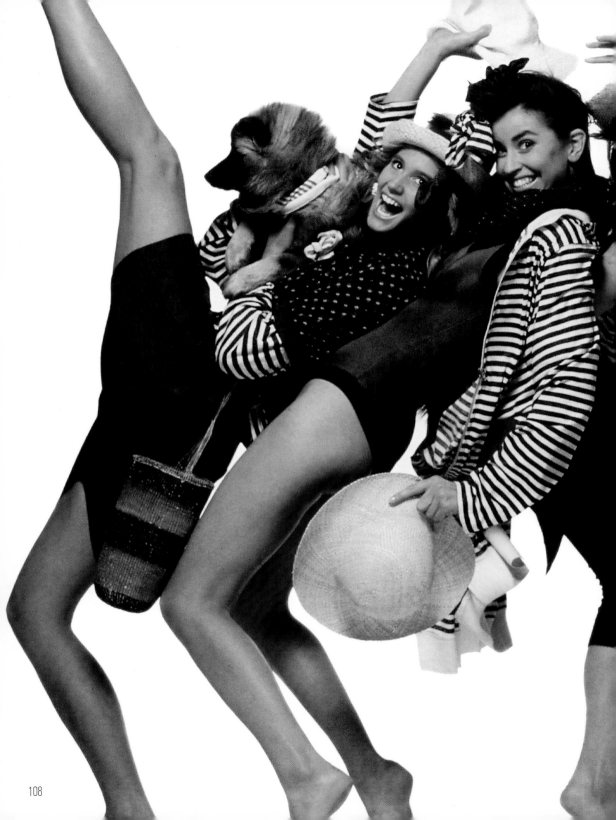

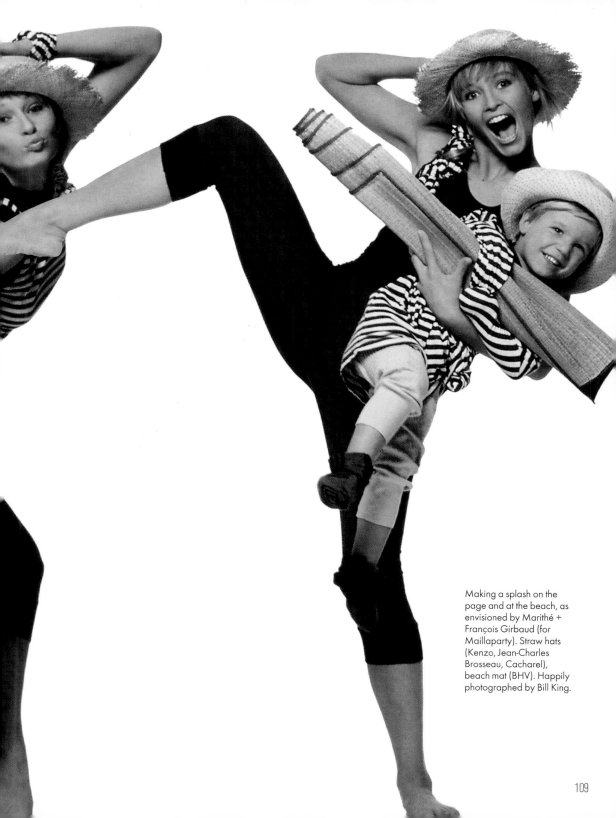

Making a splash on the page and at the beach, as envisioned by Marithé + François Girbaud (for Maillaparty). Straw hats (Kenzo, Jean-Charles Brosseau, Cacharel), beach mat (BHV). Happily photographed by Bill King.

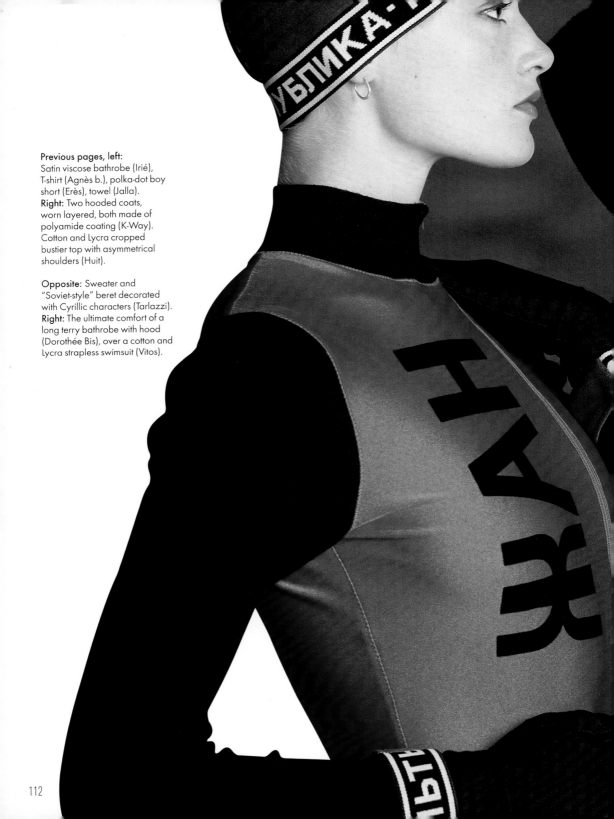

Previous pages, left:
Satin viscose bathrobe (Irié),
T-shirt (Agnès b.), polka-dot boy
short (Erès), towel (Jalla).
Right: Two hooded coats,
worn layered, both made of
polyamide coating (K-Way).
Cotton and Lycra cropped
bustier top with asymmetrical
shoulders (Huit).

Opposite: Sweater and
"Soviet-style" beret decorated
with Cyrillic characters (Tarlazzi).
Right: The ultimate comfort of a
long terry bathrobe with hood
(Dorothée Bis), over a cotton and
Lycra strapless swimsuit (Vitos).

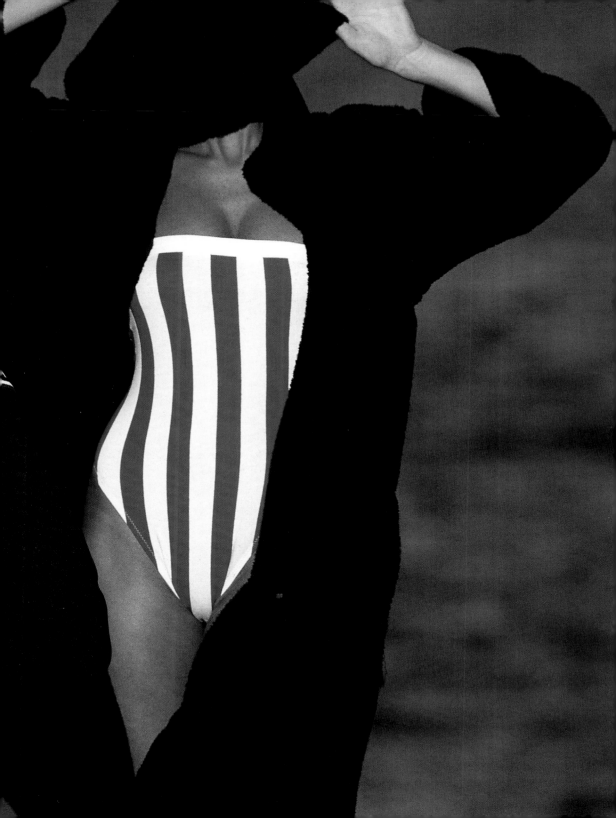

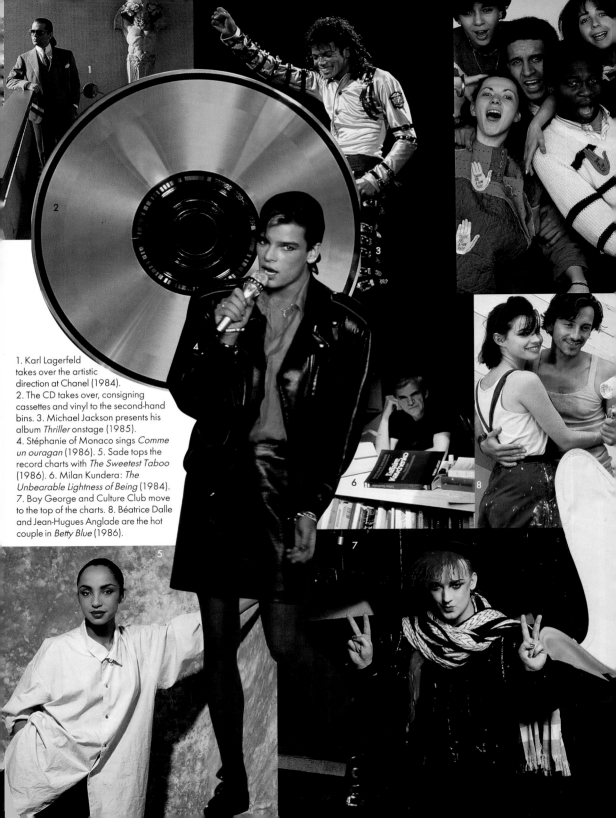

1. Karl Lagerfeld takes over the artistic direction at Chanel (1984). 2. The CD takes over, consigning cassettes and vinyl to the second-hand bins. 3. Michael Jackson presents his album *Thriller* onstage (1985). 4. Stéphanie of Monaco sings *Comme un ouragan* (1986). 5. Sade tops the record charts with *The Sweetest Taboo* (1986). 6. Milan Kundera: *The Unbearable Lightness of Being* (1984). 7. Boy George and Culture Club move to the top of the charts. 8. Béatrice Dalle and Jean-Hugues Anglade are the hot couple in *Betty Blue* (1986).

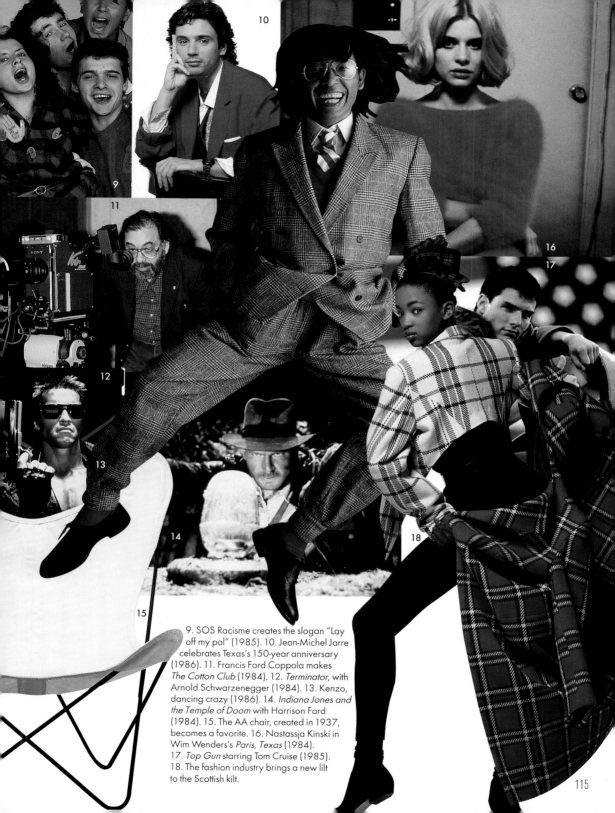

9. SOS Racisme creates the slogan "Lay off my pal" (1985). 10. Jean-Michel Jarre celebrates Texas's 150-year anniversary (1986). 11. Francis Ford Coppola makes *The Cotton Club* (1984). 12. *Terminator*, with Arnold Schwarzenegger (1984). 13. Kenzo, dancing crazy (1986). 14. *Indiana Jones and the Temple of Doom* with Harrison Ford (1984). 15. The AA chair, created in 1937, becomes a favorite. 16. Nastassja Kinski in Wim Wenders's *Paris, Texas* (1984). 17. *Top Gun* starring Tom Cruise (1985). 18. The fashion industry brings a new lilt to the Scottish kilt.

115

" Smart and smashing range of colors. "

In its November 18, 1985 "Special Beauty" issue, ELLE gives away all of the makeup secrets and tricks of its new stars, the top models.

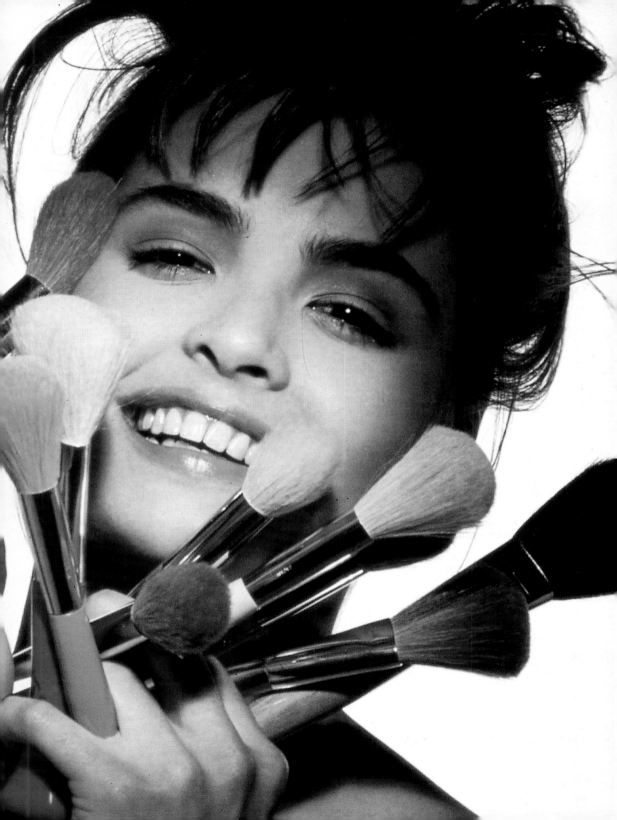

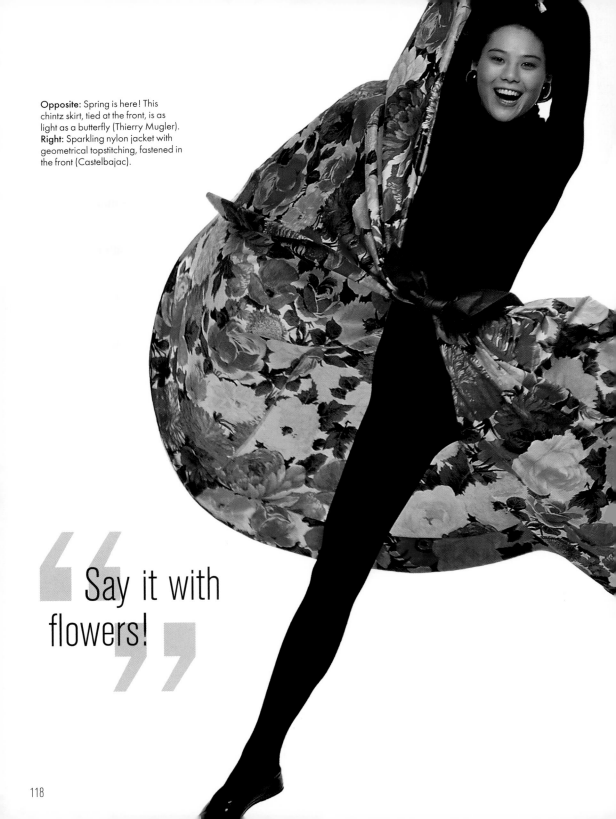

Opposite: Spring is here! This chintz skirt, tied at the front, is as light as a butterfly (Thierry Mugler).
Right: Sparkling nylon jacket with geometrical topstitching, fastened in the front (Castelbajac).

" Say it with flowers! "

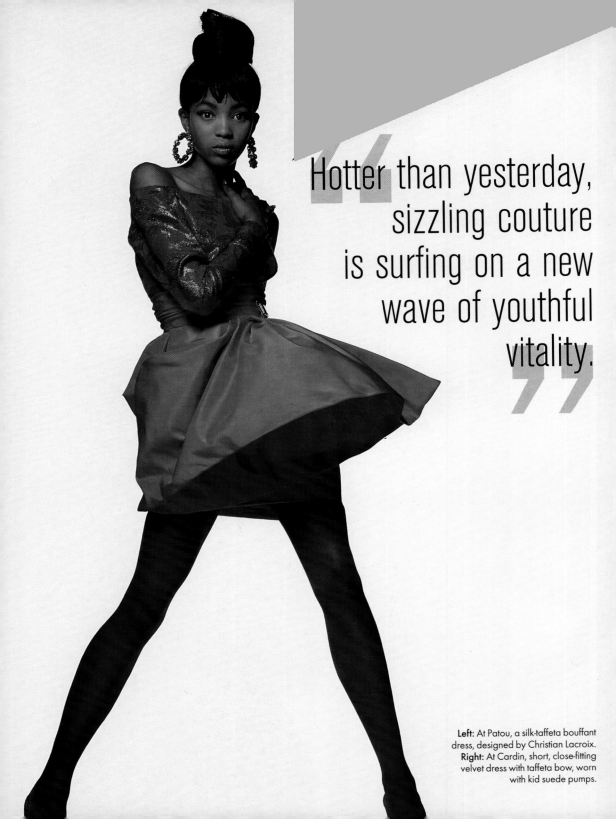

"Hotter than yesterday, sizzling couture is surfing on a new wave of youthful vitality."

Left: At Patou, a silk-taffeta bouffant dress, designed by Christian Lacroix.
Right: At Cardin, short, close-fitting velvet dress with taffeta bow, worn with kid suede pumps.

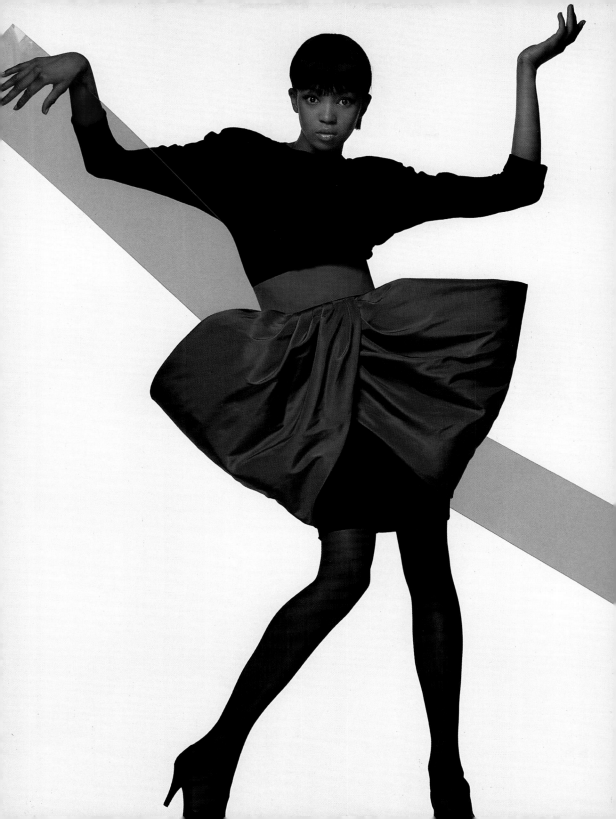

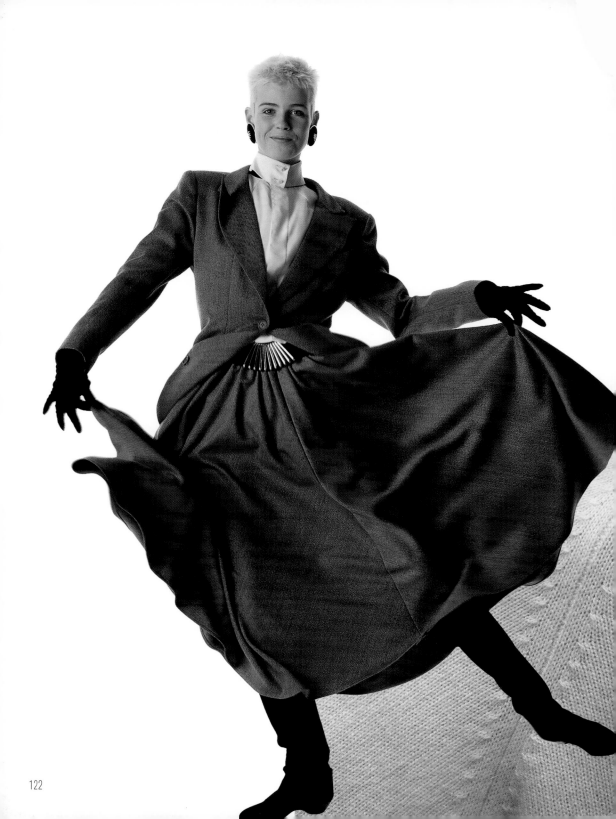

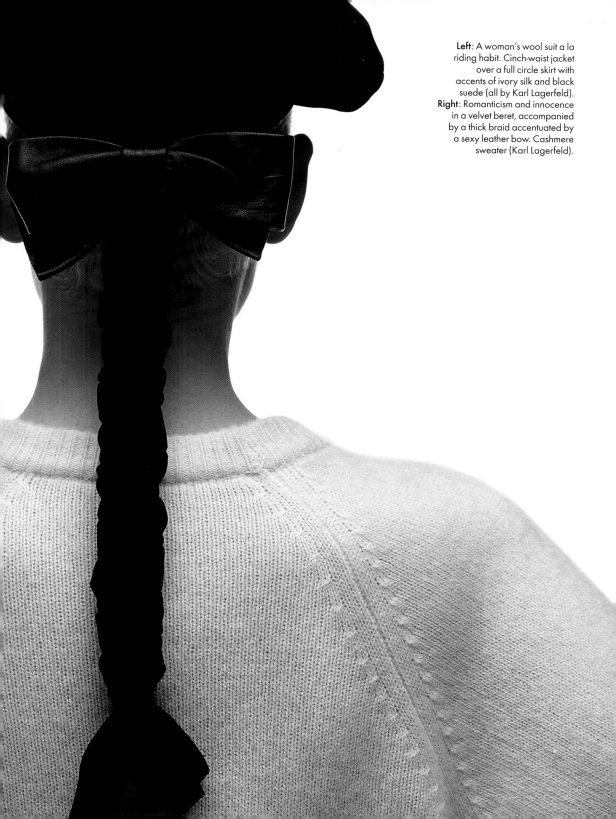

Left: A woman's wool suit a la riding habit. Cinch-waist jacket over a full circle skirt with accents of ivory silk and black suede (all by Karl Lagerfeld). **Right**: Romanticism and innocence in a velvet beret, accompanied by a thick braid accentuated by a sexy leather bow. Cashmere sweater (Karl Lagerfeld).

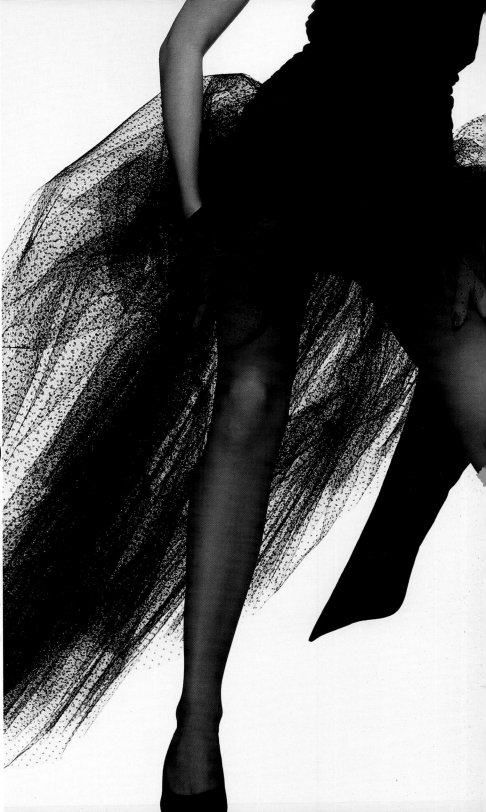

Yves Saint Laurent

The king of Paris fashion.
Left: Velvet strapless dress
draped over the hips and
skirt made of lace point
d'esprit in the spirit of Hurel
(Yves Saint Laurent haute
couture). **Right:** Black satin
ladies' suit flatteringly tight
at the waist.

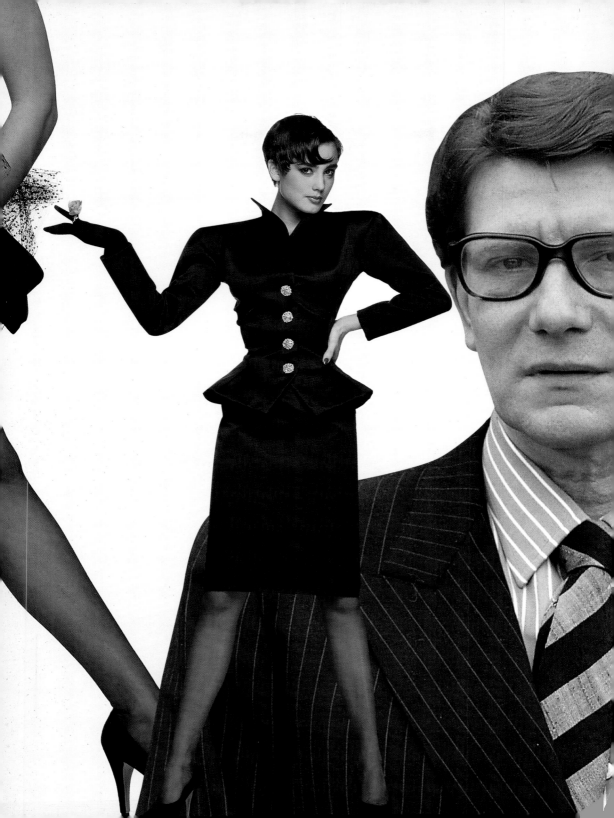

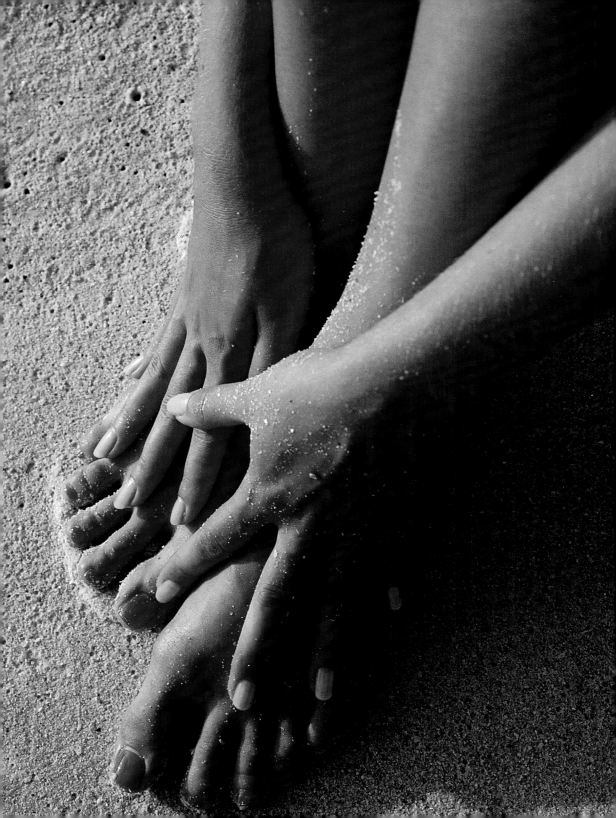

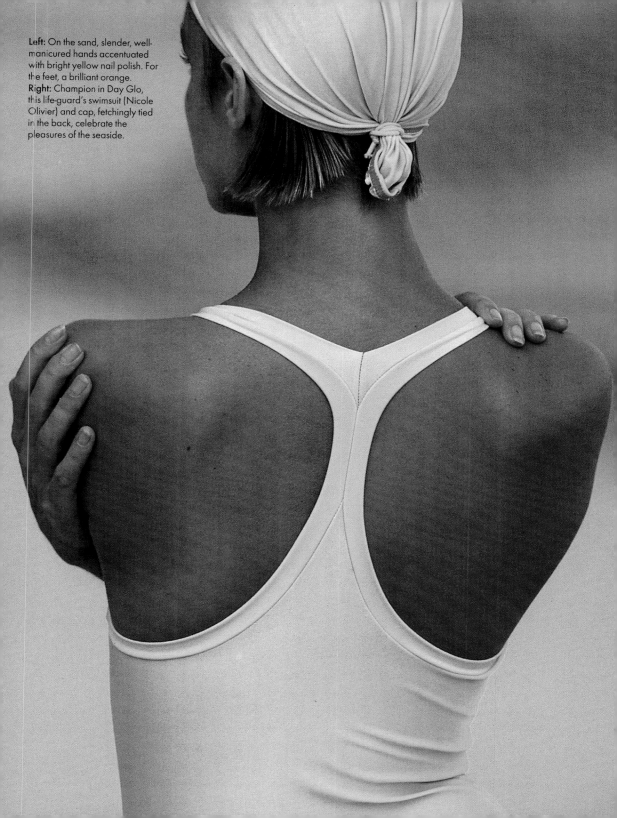

Left: On the sand, slender, well-manicured hands accentuated with bright yellow nail polish. For the feet, a brilliant orange.
Right: Champion in Day Glo, this life-guard's swimsuit (Nicole Olivier) and cap, fetchingly tied in the back, celebrate the pleasures of the seaside.

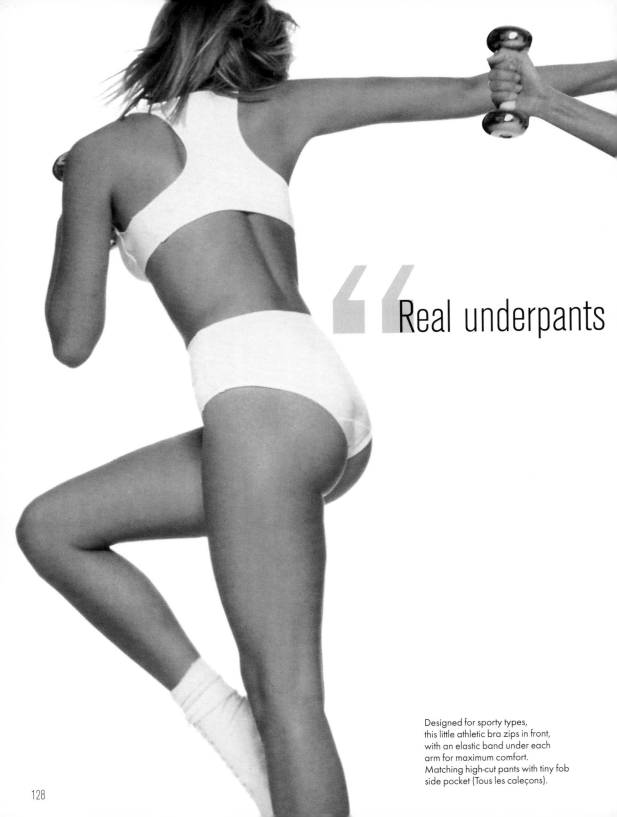

"Real underpants

Designed for sporty types,
this little athletic bra zips in front,
with an elastic band under each
arm for maximum comfort.
Matching high-cut pants with tiny fob
side pocket (Tous les caleçons).

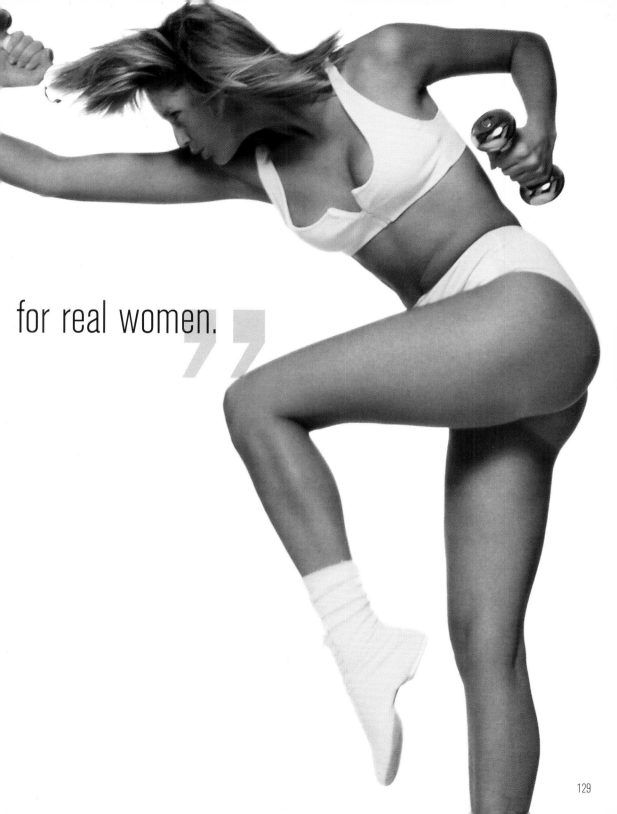

for real women. „

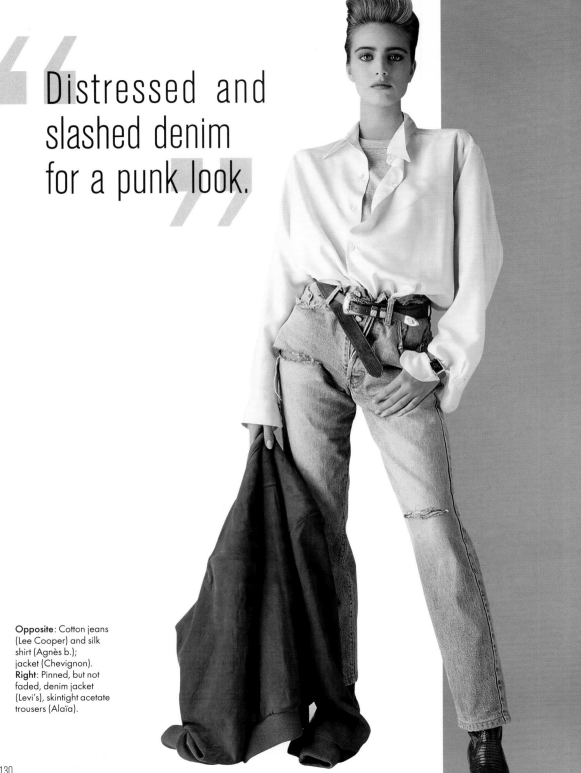

"Distressed and slashed denim for a punk look."

Opposite: Cotton jeans (Lee Cooper) and silk shirt (Agnès b.); jacket (Chevignon).
Right: Pinned, but not faded, denim jacket (Levi's), skintight acetate trousers (Alaïa).

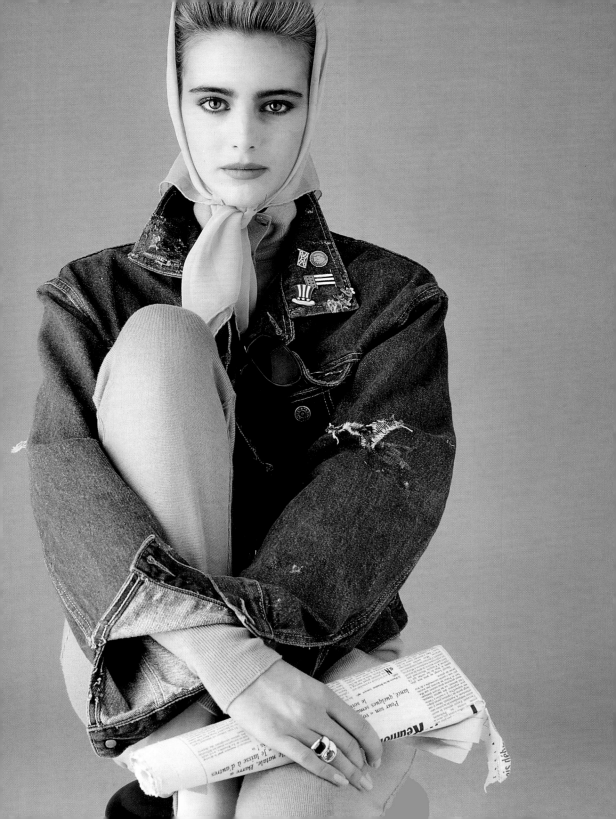

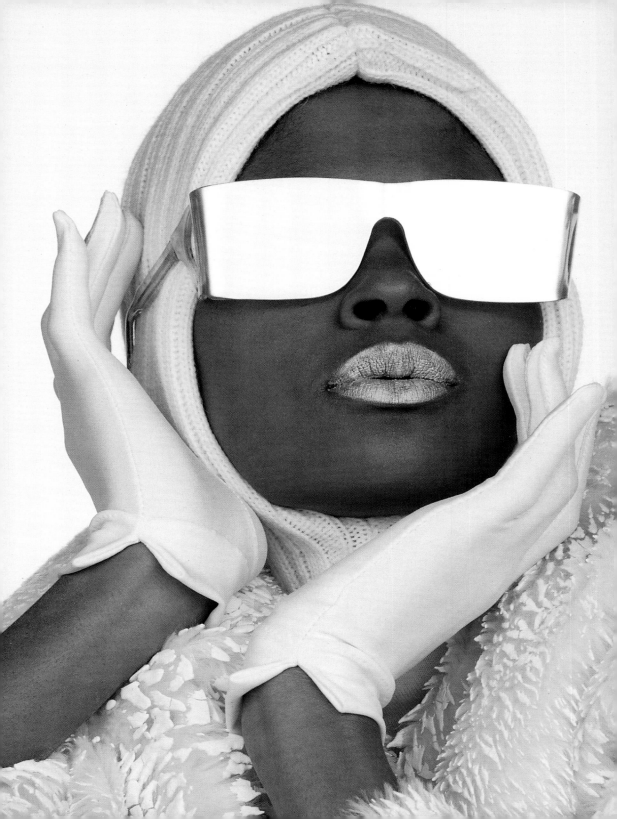

"La vie en blanc!"

Luxuriously elegant, snowy white plush mohair jacket with a generous shawl collar, worn with a ribbed wool hooded turtleneck (Thierry Mugler). Plastic glasses (Mikli), Lycra gloves (Aris).

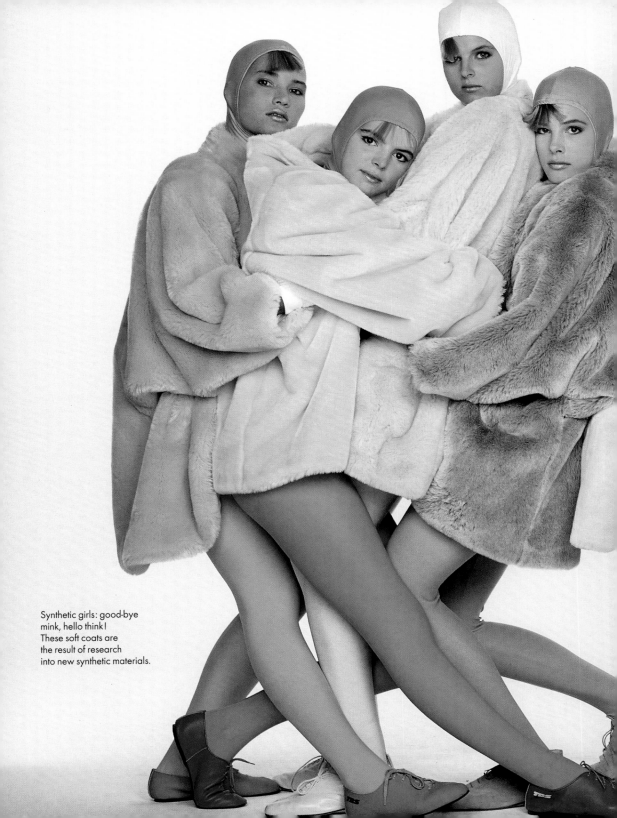

Synthetic girls: good-bye
mink, hello think!
These soft coats are
the result of research
into new synthetic materials.

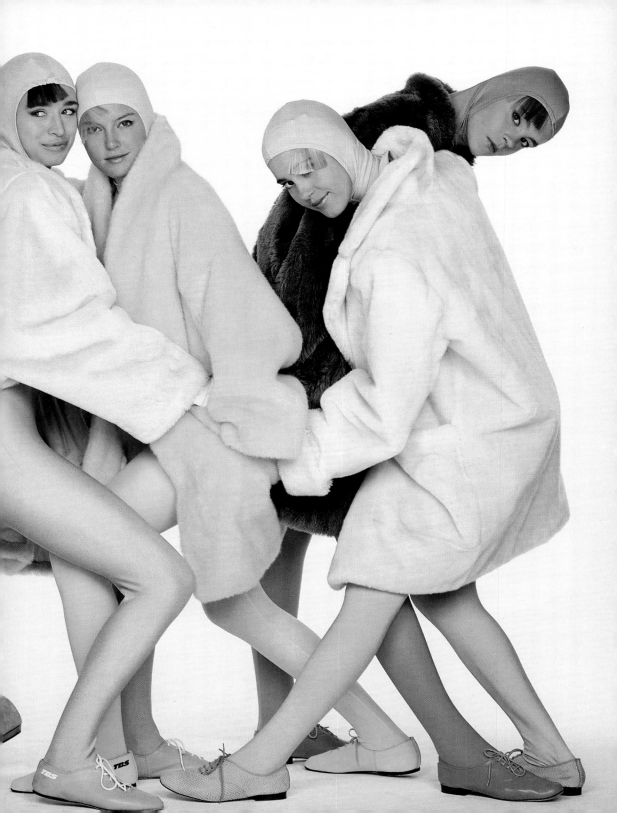

1987 ▶ American pop artist **Andy Warhol** dies, February 22. U.K. Prime Minister **Margaret Thatcher** wins rare third term, June 11. Death of **Fred Astaire**, the man with the golden feet, June 22. **New York Stock Market** crashes to an all-time low of 22.6%, October 19. The **Dior House** turns 40. Madonna's **Who's That Girl** tour has worldwide success. **Prozac** is released for use in the United States by Eli Lilly & Company. 50,000 people gather at **Graceland** on the 10th anniversary of Elvis's death, August 16.

1988 ▶ Canadian sprinter **Ben Johnson** tests positive for **steroids** and has gold medals revoked at Seoul Olympics. **Naguib Mahfouz** wins Nobel Prize for Literature. **USSR** plans to withdraw from Afghanistan. **Nobel Peace Prize** goes to **United Nations Peacekeeping Forces**. CDs outsell vinyl records for the first time. **Pan Am Flight 103** explodes over Lockerbie, Scotland, killing 270 people and prompting talk of terrorism, December 21. At the **movies**: Stephen Frears's **Dangerous Liaisons** introduces actor **John Malkovich**.

1989 ▶ Death of **Salvador Dalí**, January 23. **Exxon Valdez** oil spill: ruptured tank sends 11 million gallons of crude oil into Alaska's Prince William Sound, March 24. **Polish government** is formed by **Solidarnosc**. Comedian **Lucille Ball** dies, April 26. An estimated 5,000 are killed in Beijing's **Tiananmen Square** during rally for democracy, June 3. **Salman Rushdie**'s controversial novel **The Satanic Verses** is published. U.S. Grammy Record of the Year: George Michael's **Faith**. Fall of the **Berlin Wall**, November 9. Cost of a **U.S. first-class stamp**: $0.25.

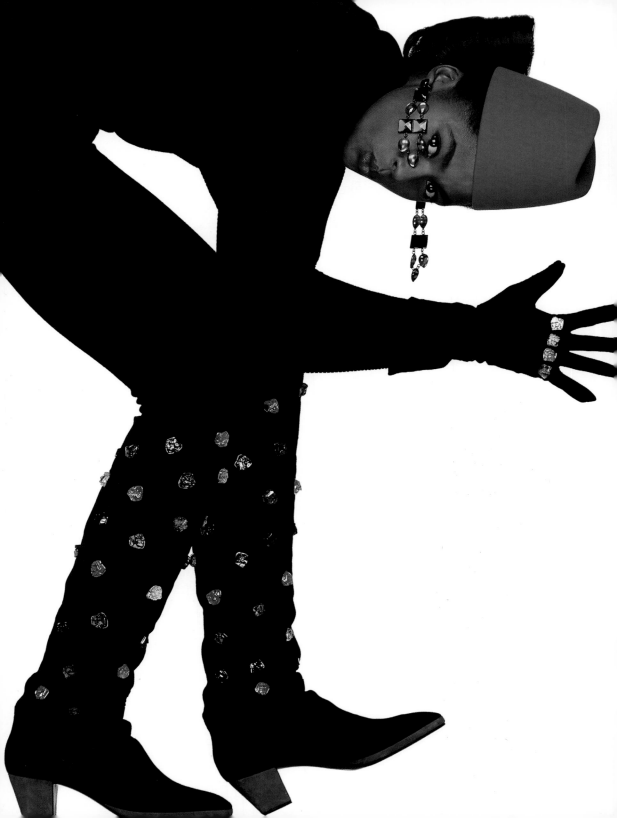

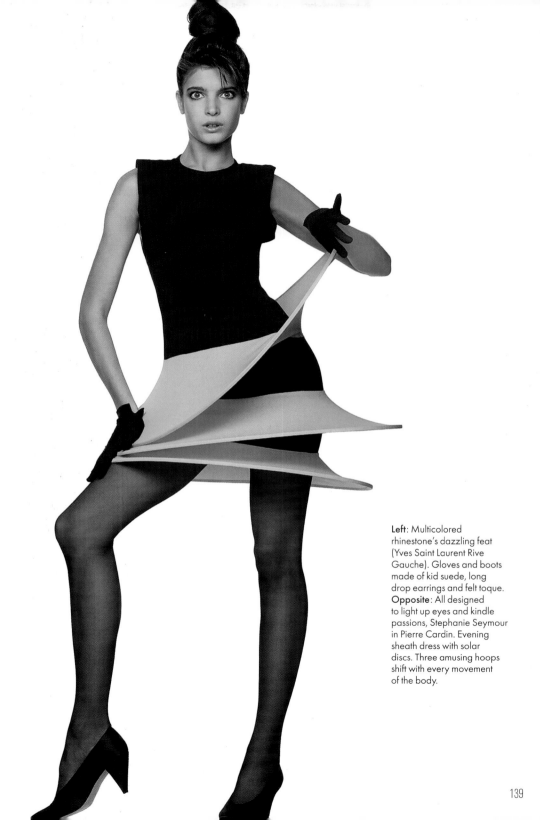

Left: Multicolored rhinestone's dazzling feat (Yves Saint Laurent Rive Gauche). Gloves and boots made of kid suede, long drop earrings and felt toque.
Opposite: All designed to light up eyes and kindle passions, Stephanie Seymour in Pierre Cardin. Evening sheath dress with solar discs. Three amusing hoops shift with every movement of the body.

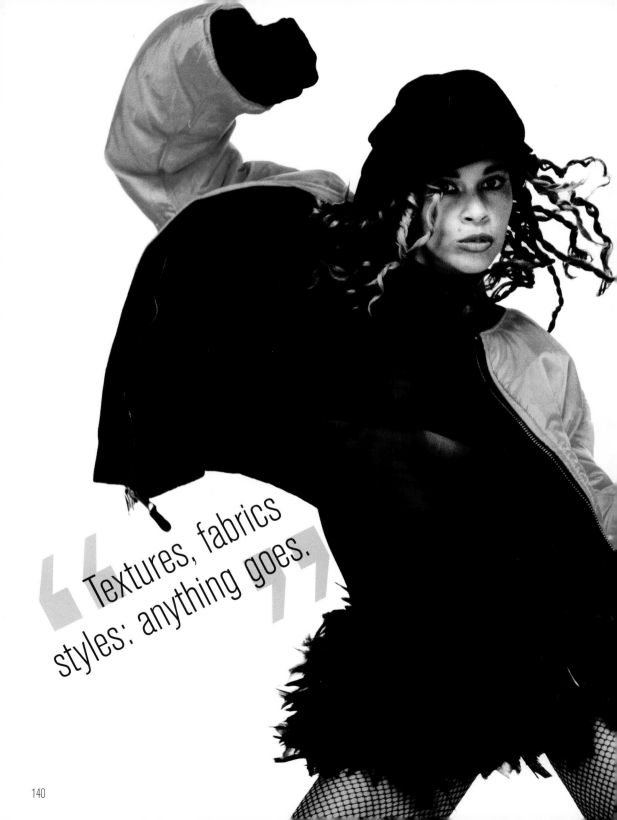

"Textures, fabrics styles: anything goes."

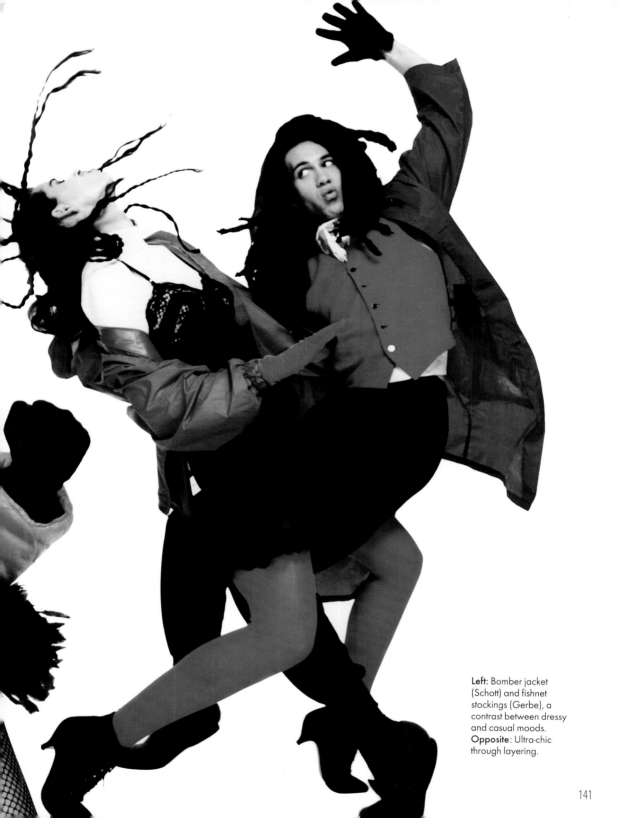

Left: Bomber jacket (Schott) and fishnet stockings (Gerbe), a contrast between dressy and casual moods. **Opposite:** Ultra-chic through layering.

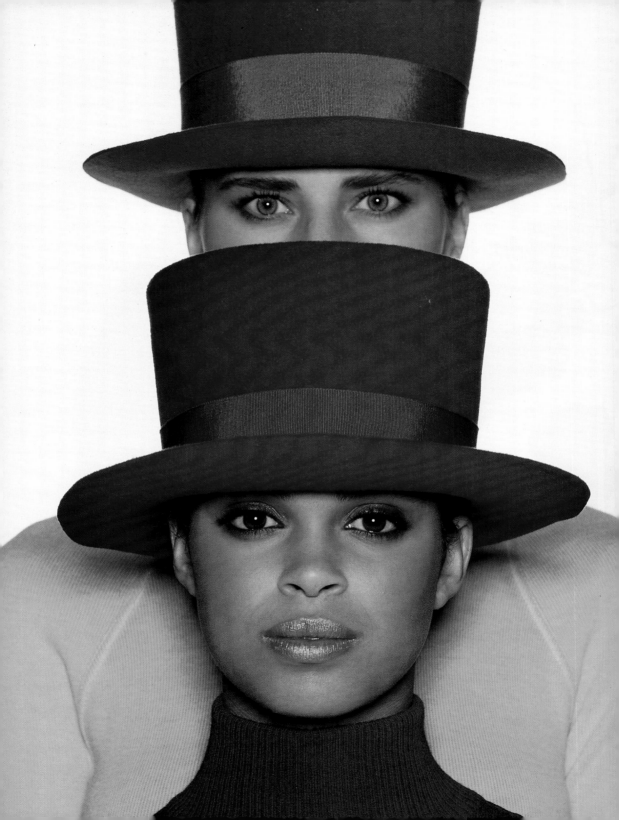

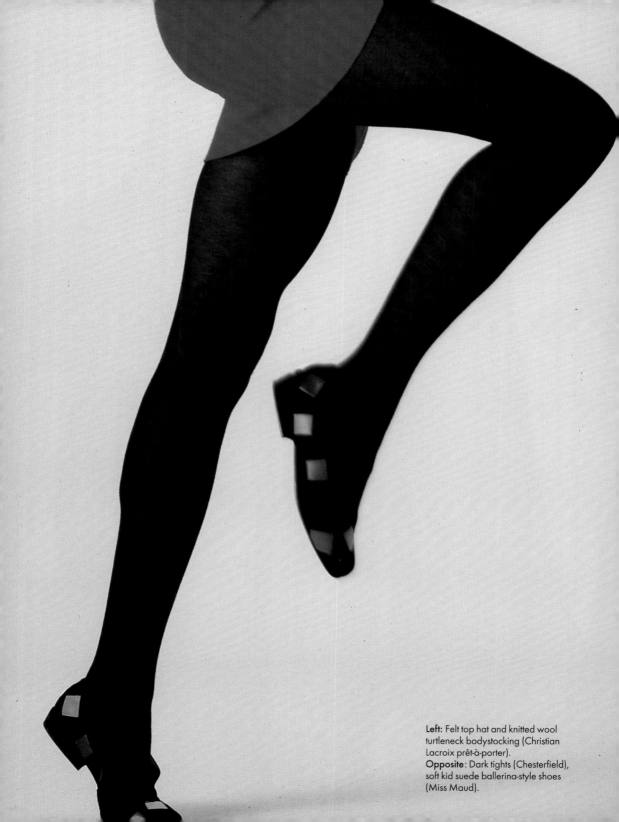

Left: Felt top hat and knitted wool turtleneck bodystocking (Christian Lacroix prêt-à-porter).
Opposite: Dark tights (Chesterfield), soft kid suede ballerina-style shoes (Miss Maud).

Castelbajac

Jean-Charles de Castelbajac's bright shades for multicolored dresses, parkas and windbreakers.

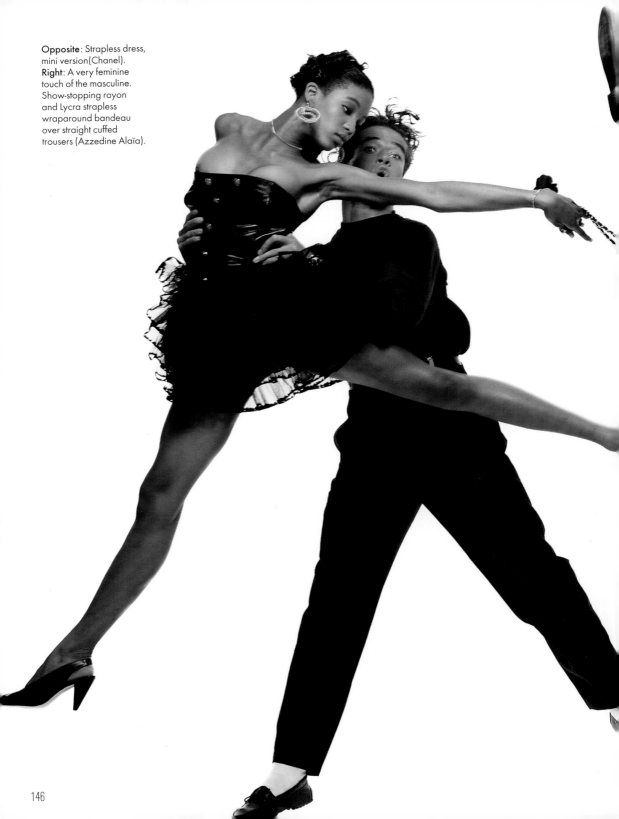

Opposite: Strapless dress, mini version (Chanel).
Right: A very feminine touch of the masculine. Show-stopping rayon and Lycra strapless wraparound bandeau over straight cuffed trousers (Azzedine Alaïa).

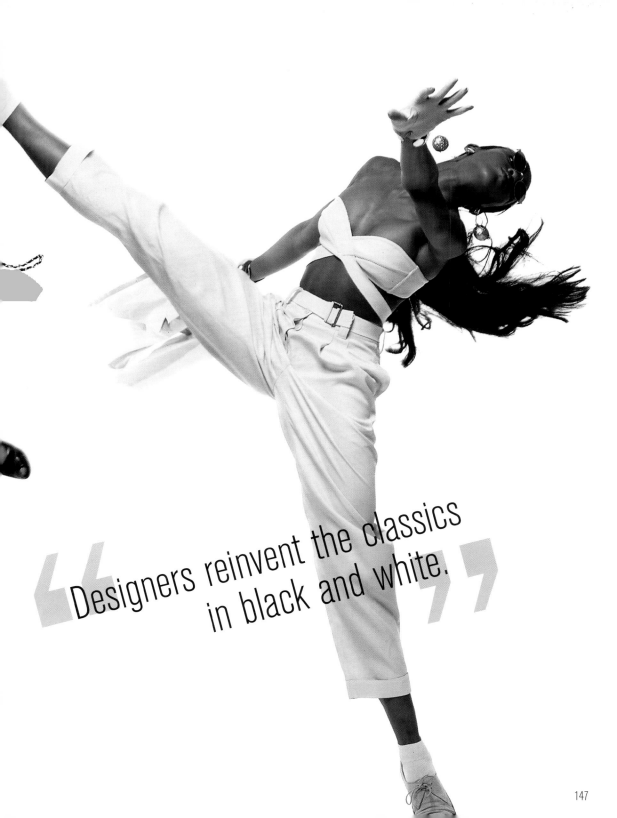

"Designers reinvent the classics in black and white."

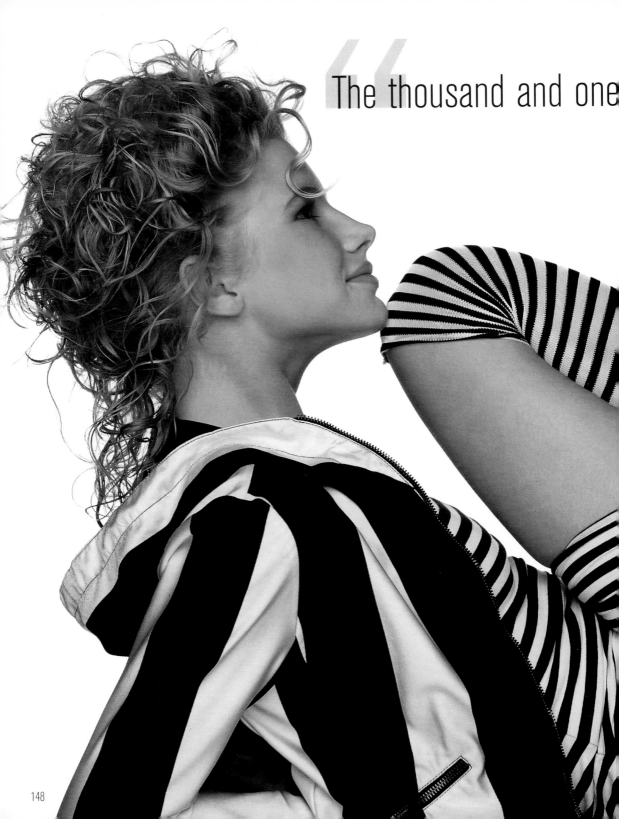

lines of fashion.

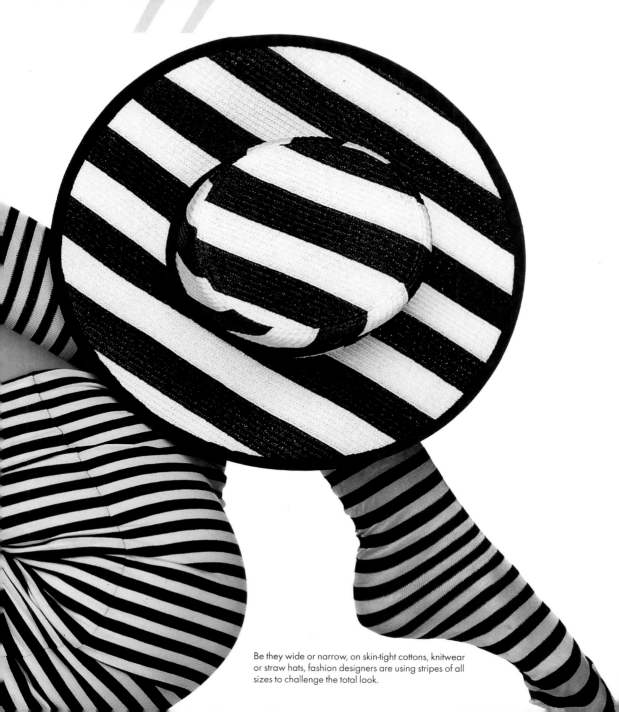

Be they wide or narrow, on skin-tight cottons, knitwear or straw hats, fashion designers are using stripes of all sizes to challenge the total look.

"A new angle on stripes."

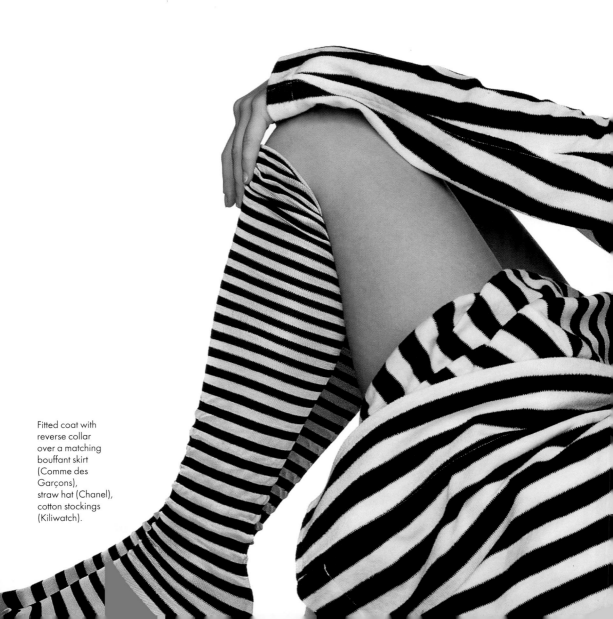

Fitted coat with
reverse collar
over a matching
bouffant skirt
(Comme des
Garçons),
straw hat (Chanel),
cotton stockings
(Kiliwatch).

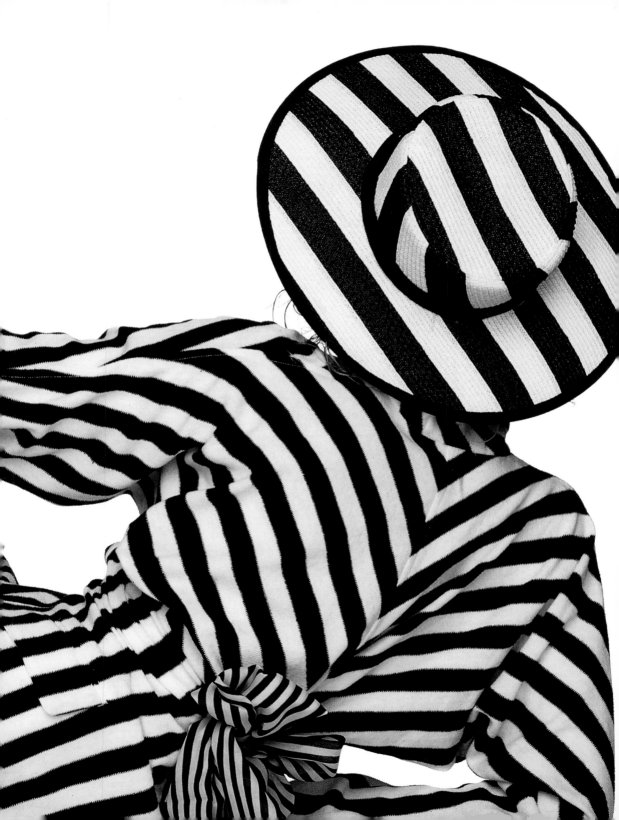

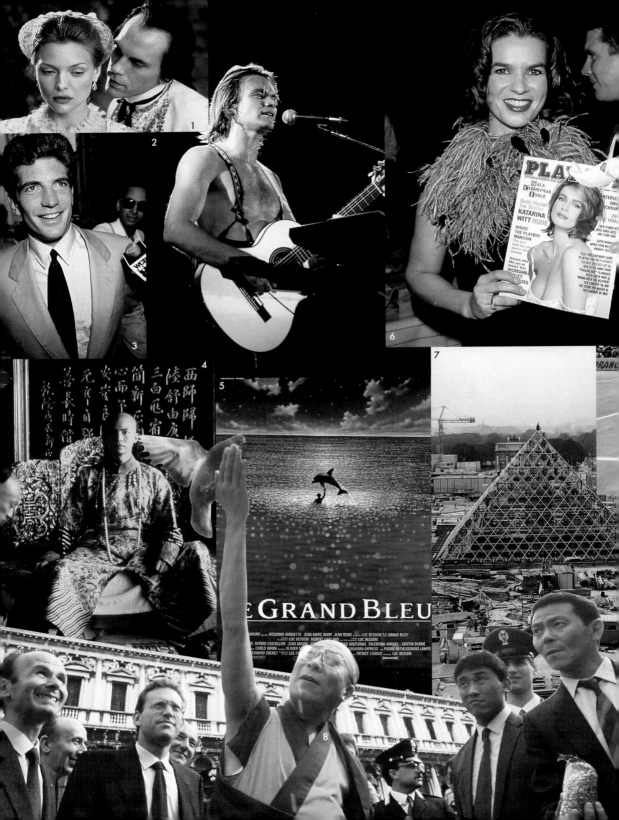

E GRAND BLEU

GAUMONT présente ROSANNA ARQUETTE · JEAN-MARC BARR · JEAN RENO dans un film de LUC BESSON "LE GRAND BLEU"

avec SERGIO CASTELLITO · JEAN BOUISE · MARC ... · ... VOUTSINAS · VALENTINA VARGAS · GRIFFIN DUNNE

... CARLO VARINI ... OLIVIER BETTE / MARC ... CREATION-EXPRESS ... PIERRE BEFVE/GERARD LAMPS

... BERNARD GRENET ... LES F... ... PATRICE LEDOUX ... LUC BESSON

1

2

3

4

5

6

7

8

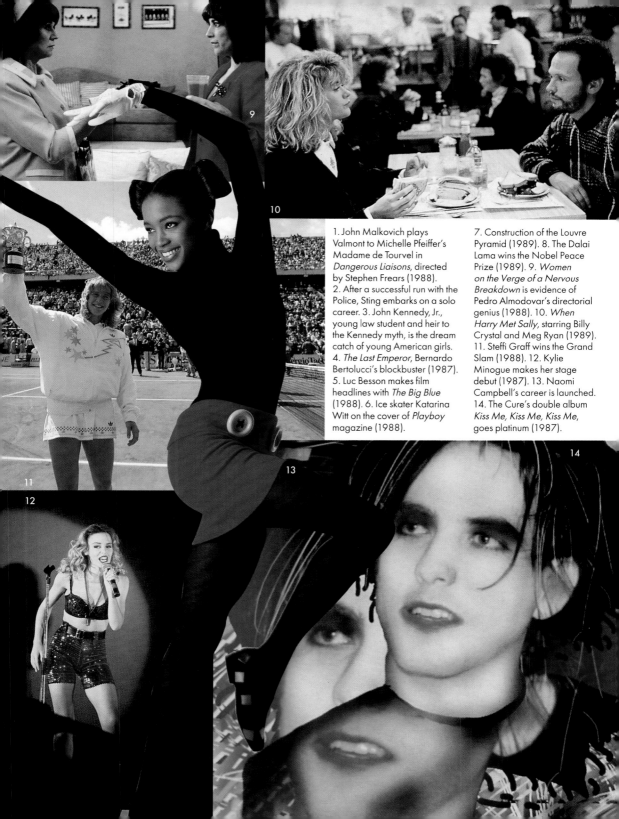

1. John Malkovich plays Valmont to Michelle Pfeiffer's Madame de Tourvel in *Dangerous Liaisons*, directed by Stephen Frears (1988). 2. After a successful run with the Police, Sting embarks on a solo career. 3. John Kennedy, Jr., young law student and heir to the Kennedy myth, is the dream catch of young American girls. 4. *The Last Emperor*, Bernardo Bertolucci's blockbuster (1987). 5. Luc Besson makes film headlines with *The Big Blue* (1988). 6. Ice skater Katarina Witt on the cover of *Playboy* magazine (1988). 7. Construction of the Louvre Pyramid (1989). 8. The Dalai Lama wins the Nobel Peace Prize (1989). 9. *Women on the Verge of a Nervous Breakdown* is evidence of Pedro Almodovar's directorial genius (1988). 10. *When Harry Met Sally*, starring Billy Crystal and Meg Ryan (1989). 11. Steffi Graff wins the Grand Slam (1988). 12. Kylie Minogue makes her stage debut (1987). 13. Naomi Campbell's career is launched. 14. The Cure's double album *Kiss Me, Kiss Me, Kiss Me*, goes platinum (1987).

"Hot and cool quicksilver!"

Ever futuristic, Barbarella '87 sets off in pursuit
of synthetic fabrics. Textured crossover jacket gleams
like a space blanket. Robotic look that catches the light
(Jean-Rémy Daumas at Claire-Marine).

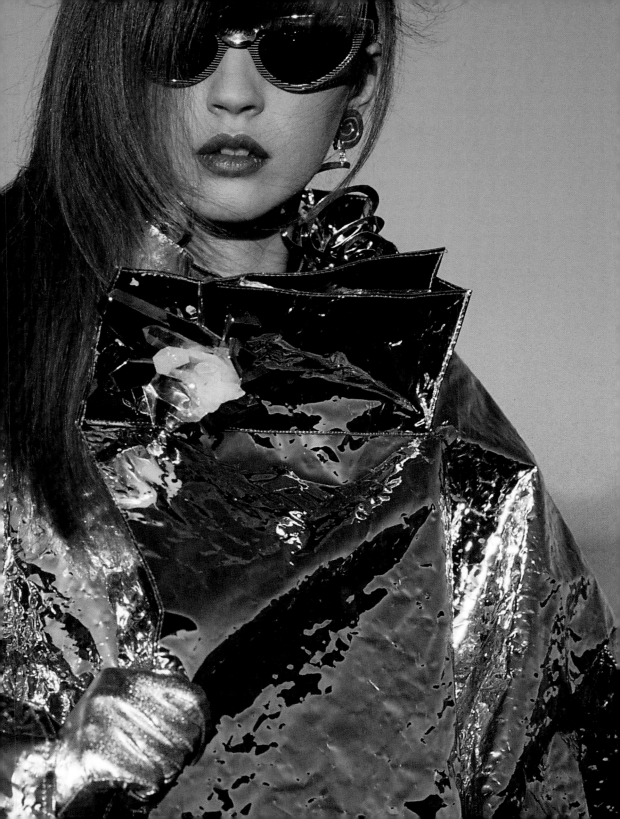

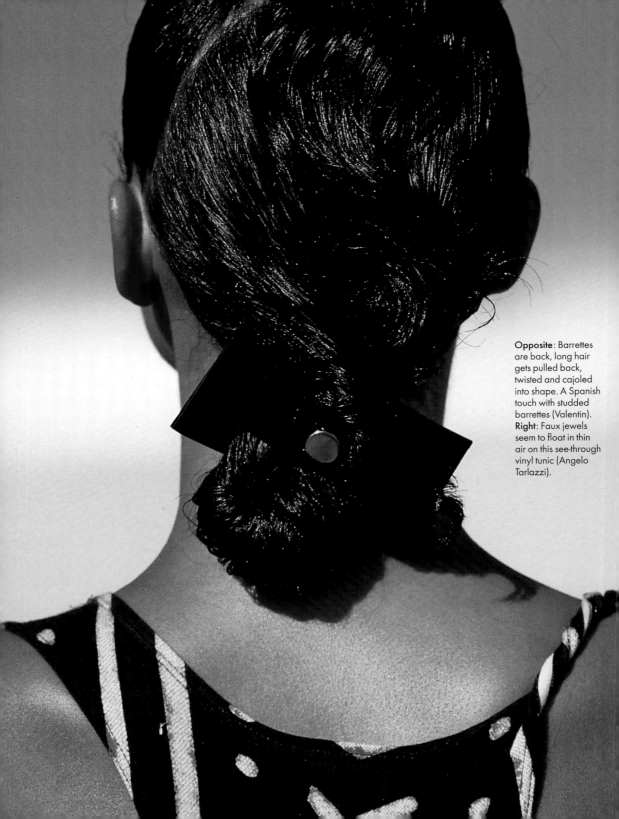

Opposite: Barrettes are back, long hair gets pulled back, twisted and cajoled into shape. A Spanish touch with studded barrettes (Valentin). **Right**: Faux jewels seem to float in thin air on this see-through vinyl tunic (Angelo Tarlazzi).

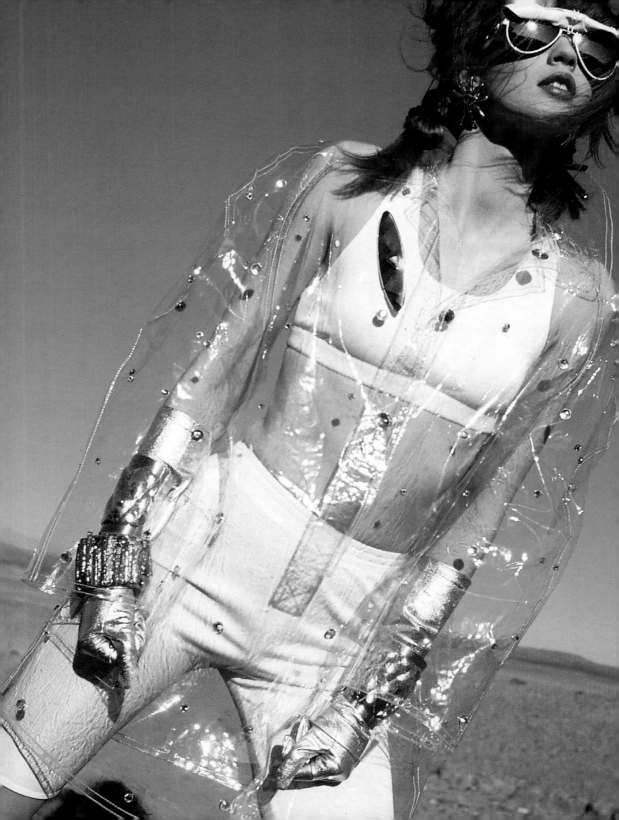

Claude Montana

The body is emphasized, but wrapped in such a way as to create a rounded, comfortable and nonchalant figure. Montana, a designer who loves women; but not just any woman, and not just any old how.

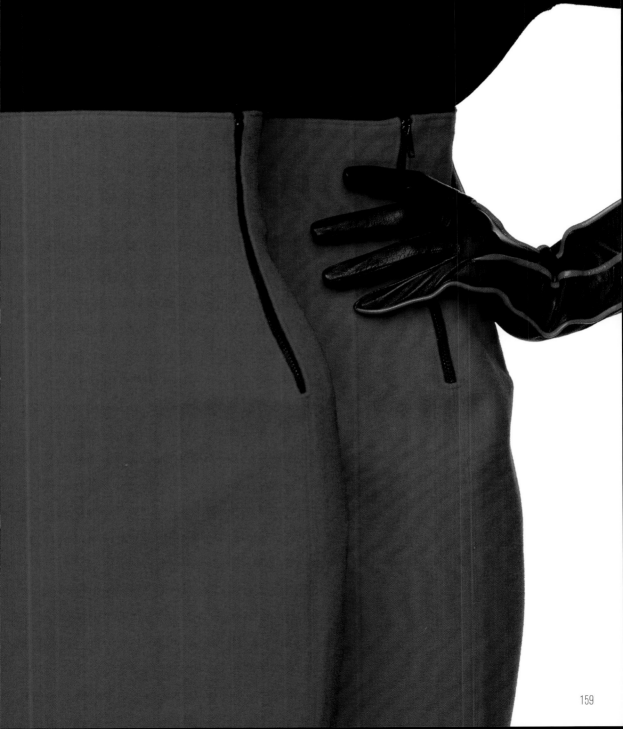

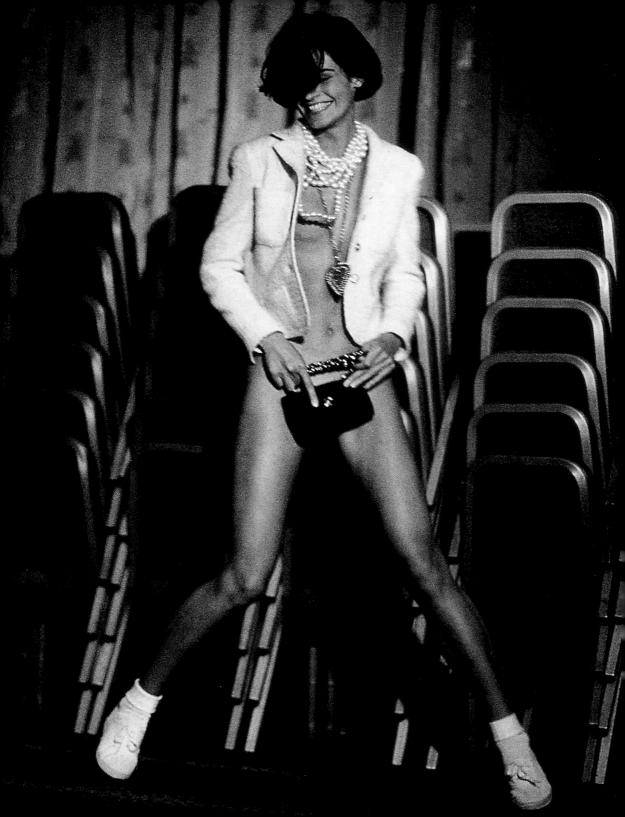

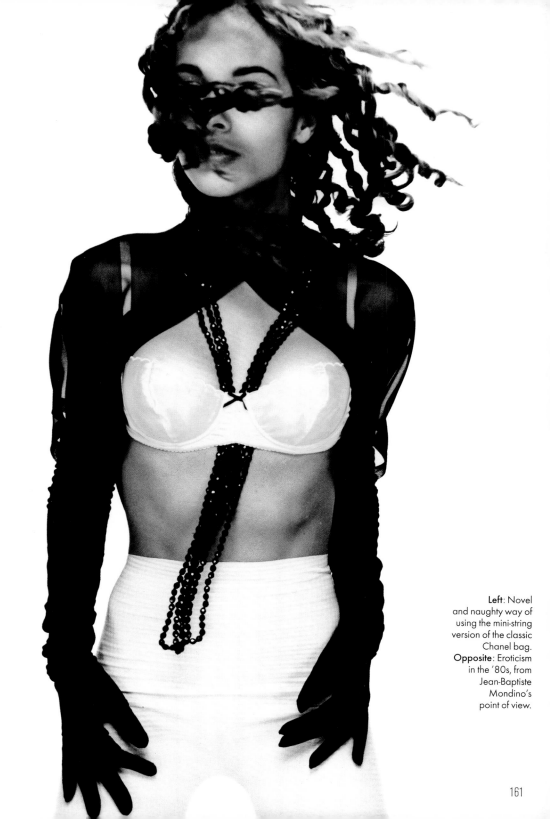

Left: Novel and naughty way of using the mini-string version of the classic Chanel bag. **Opposite**: Eroticism in the '80s, from Jean-Baptiste Mondino's point of view.

161

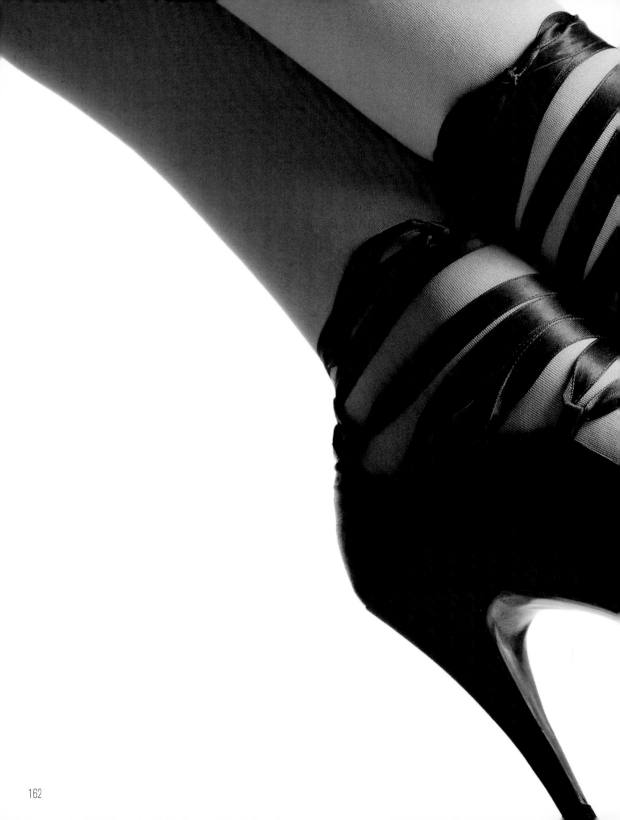

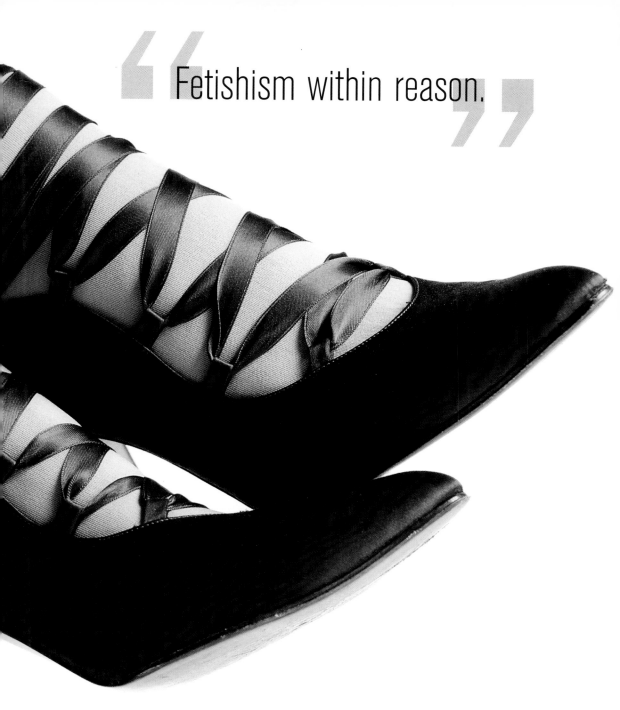

"Fetishism within reason."

By creating shoes that never go unnoticed, Christian Lacroix fetishizes the foot. Take these lace-up high heels, to be untied slowly.

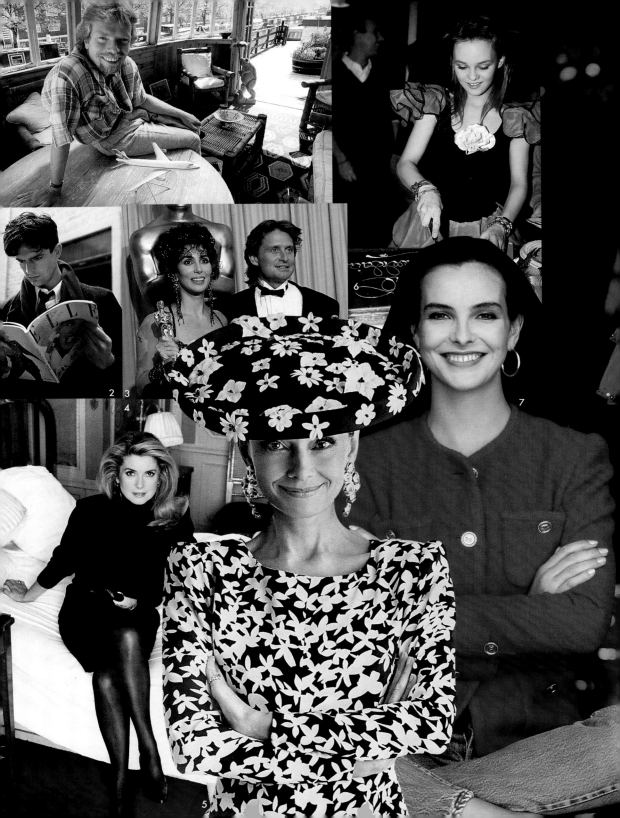

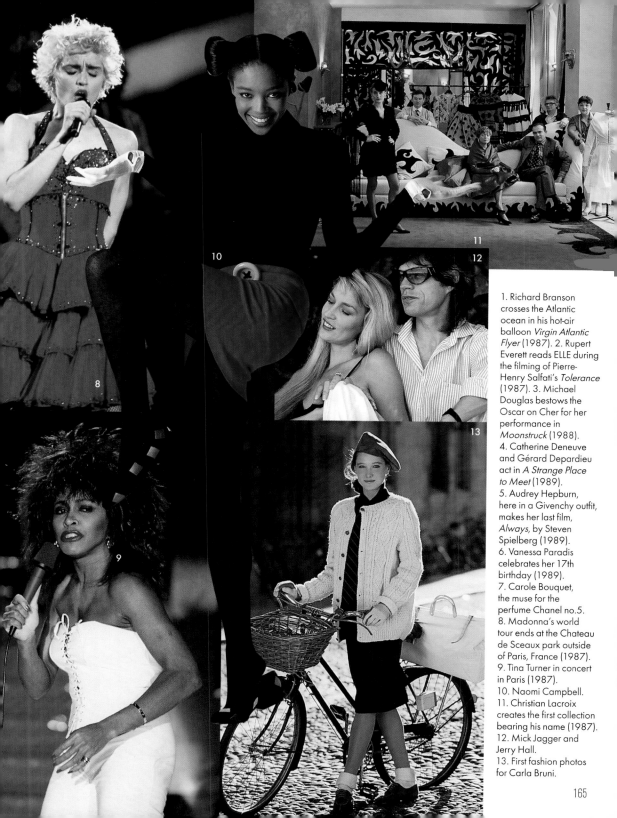

1. Richard Branson crosses the Atlantic ocean in his hot-air balloon *Virgin Atlantic Flyer* (1987). 2. Rupert Everett reads ELLE during the filming of Pierre-Henry Salfati's *Tolerance* (1987). 3. Michael Douglas bestows the Oscar on Cher for her performance in *Moonstruck* (1988). 4. Catherine Deneuve and Gérard Depardieu act in *A Strange Place to Meet* (1989). 5. Audrey Hepburn, here in a Givenchy outfit, makes her last film, *Always*, by Steven Spielberg (1989). 6. Vanessa Paradis celebrates her 17th birthday (1989). 7. Carole Bouquet, the muse for the perfume Chanel no.5. 8. Madonna's world tour ends at the Chateau de Sceaux park outside of Paris, France (1987). 9. Tina Turner in concert in Paris (1987). 10. Naomi Campbell. 11. Christian Lacroix creates the first collection bearing his name (1987). 12. Mick Jagger and Jerry Hall. 13. First fashion photos for Carla Bruni.

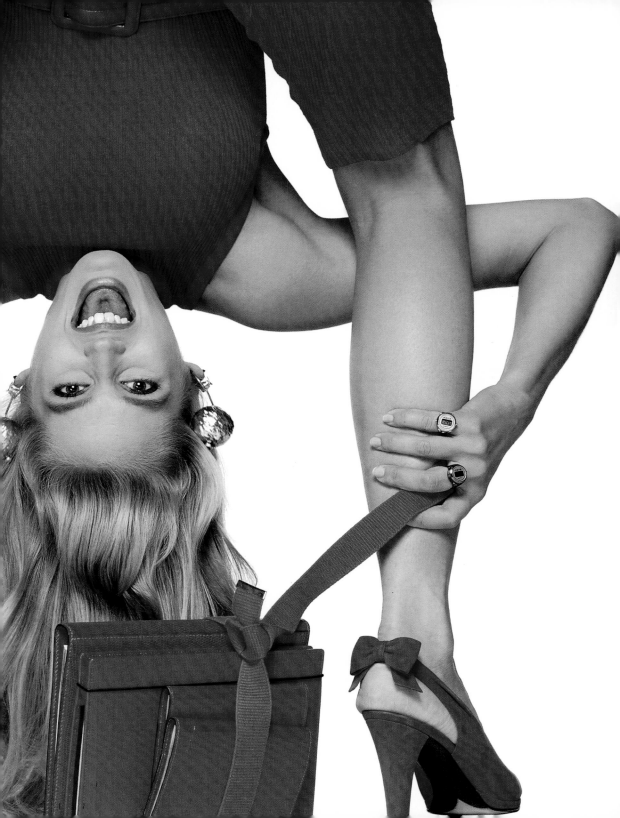

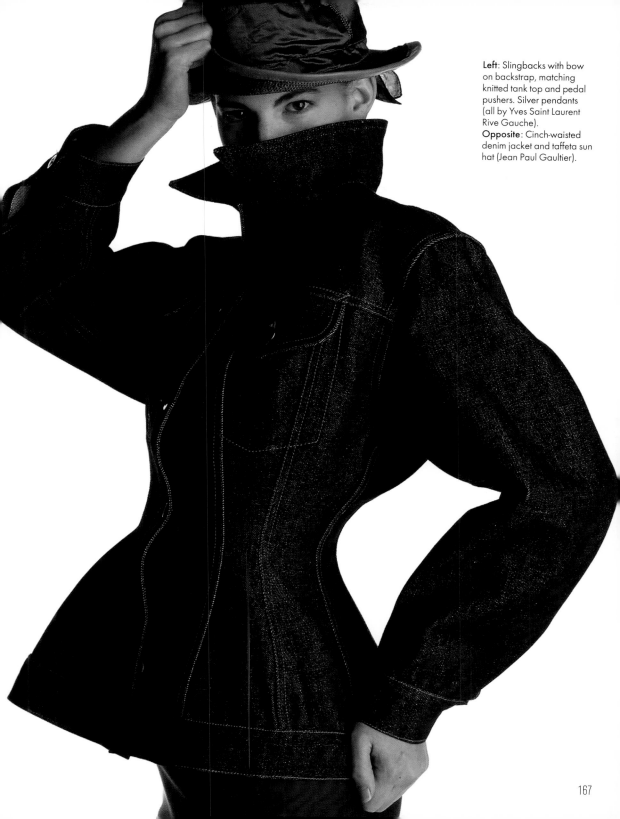

Left: Slingbacks with bow on backstrap, matching knitted tank top and pedal pushers. Silver pendants (all by Yves Saint Laurent Rive Gauche).
Opposite: Cinch-waisted denim jacket and taffeta sun hat (Jean Paul Gaultier).

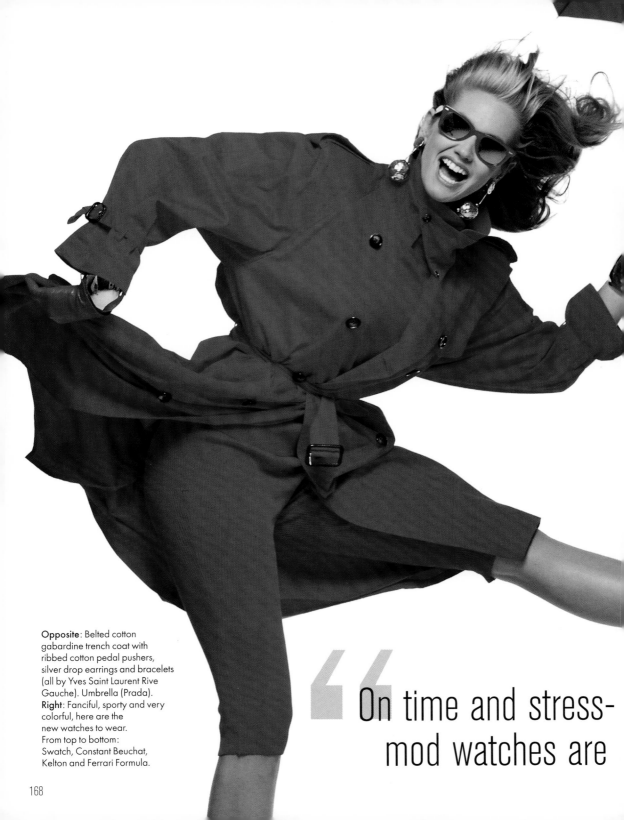

Opposite: Belted cotton
gabardine trench coat with
ribbed cotton pedal pushers,
silver drop earrings and bracelets
(all by Yves Saint Laurent Rive
Gauche). Umbrella (Prada).
Right: Fanciful, sporty and very
colorful, here are the
new watches to wear.
From top to bottom:
Swatch, Constant Beuchat,
Kelton and Ferrari Formula.

" On time and stress-
mod watches are

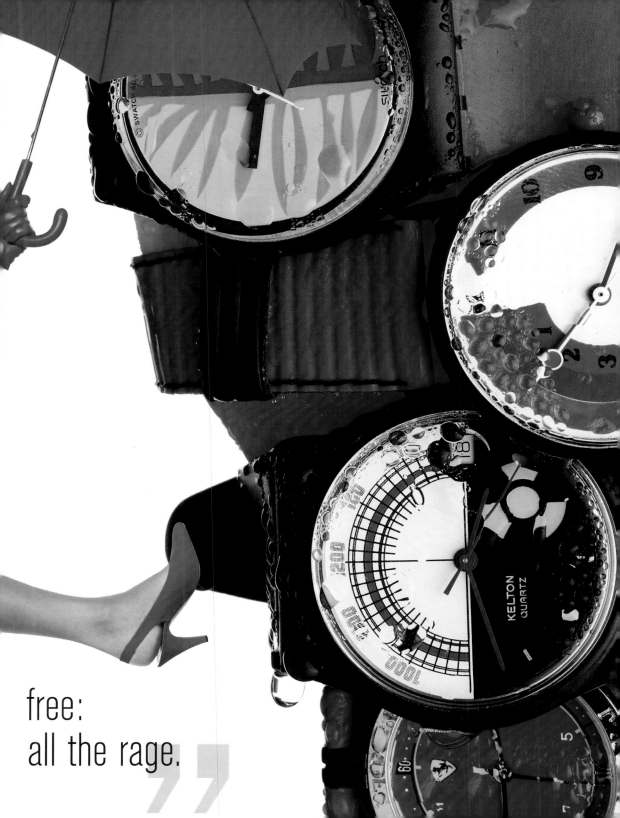

free:
all the rage.

Agnès b.

The spirit of Agnès b.:
A hymn to simplicity by
a designer whose clothes
put comfort first.
Opposite: Wool gabardine
women's suit, buttonless
double-breasted jacket and
short, straight skirt.

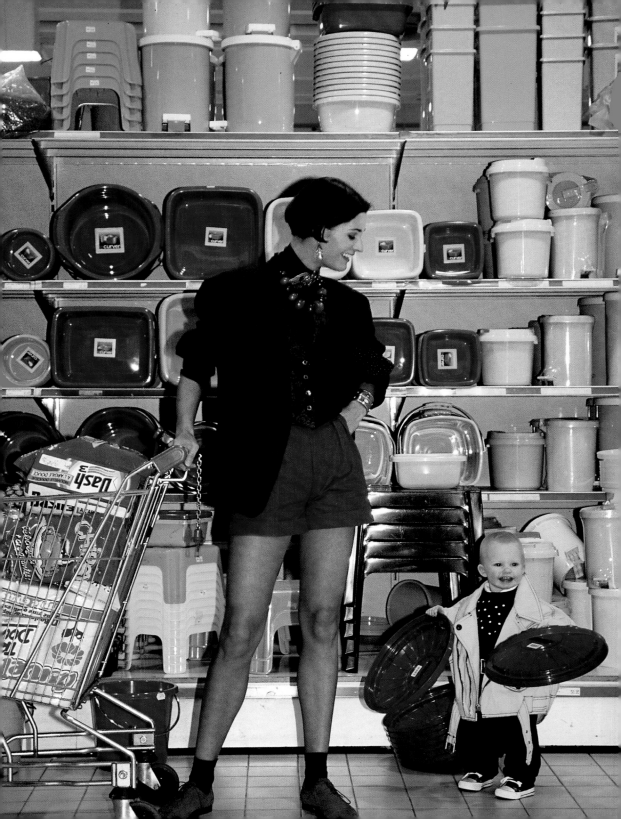

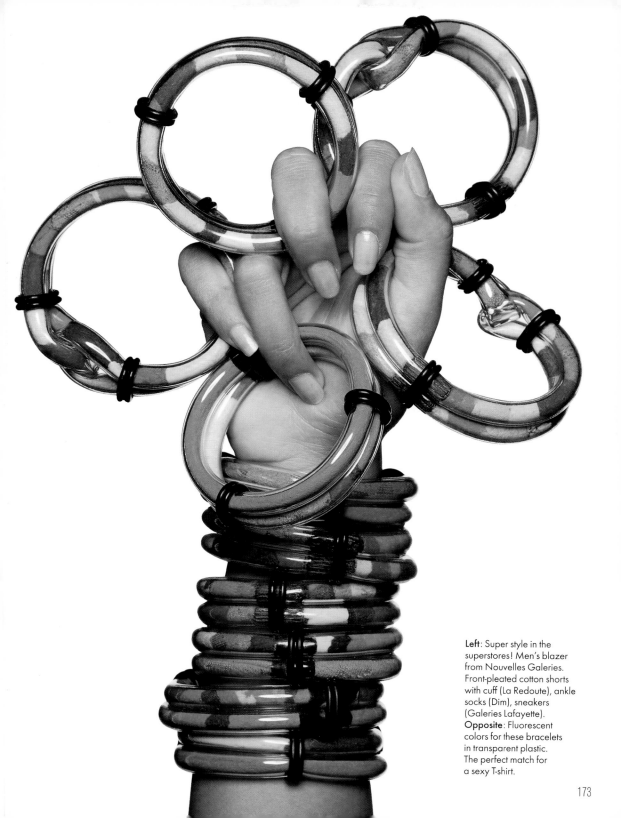

Left: Super style in the superstores! Men's blazer from Nouvelles Galeries. Front-pleated cotton shorts with cuff (La Redoute), ankle socks (Dim), sneakers (Galeries Lafayette). Opposite: Fluorescent colors for these bracelets in transparent plastic. The perfect match for a sexy T-shirt.

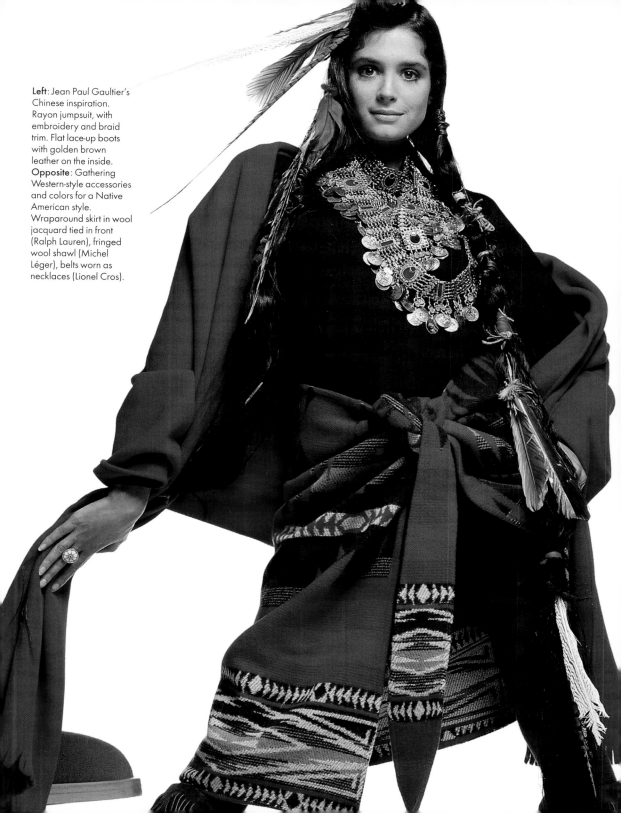

Left: Jean Paul Gaultier's Chinese inspiration. Rayon jumpsuit, with embroidery and braid trim. Flat lace-up boots with golden brown leather on the inside.
Opposite: Gathering Western-style accessories and colors for a Native American style. Wraparound skirt in wool jacquard tied in front (Ralph Lauren), fringed wool shawl (Michel Léger), belts worn as necklaces (Lionel Cros).

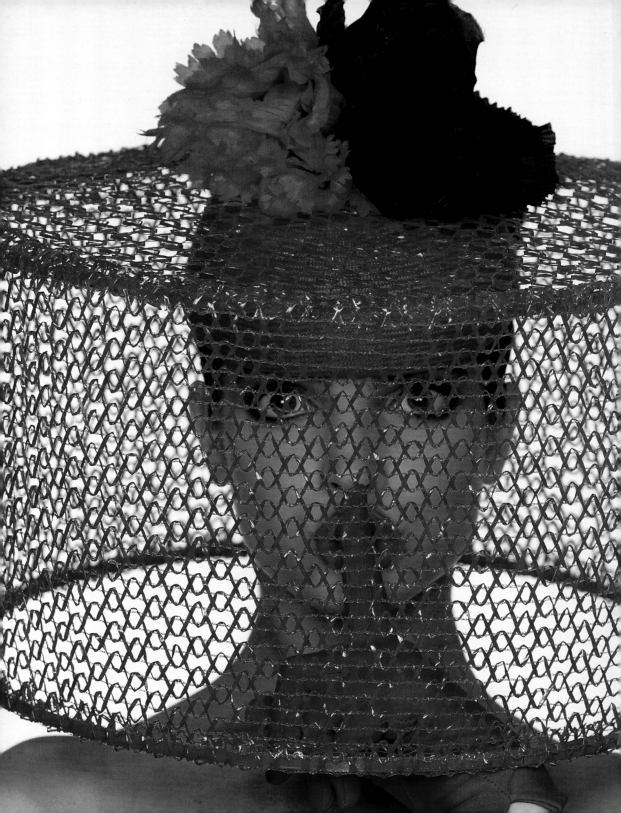

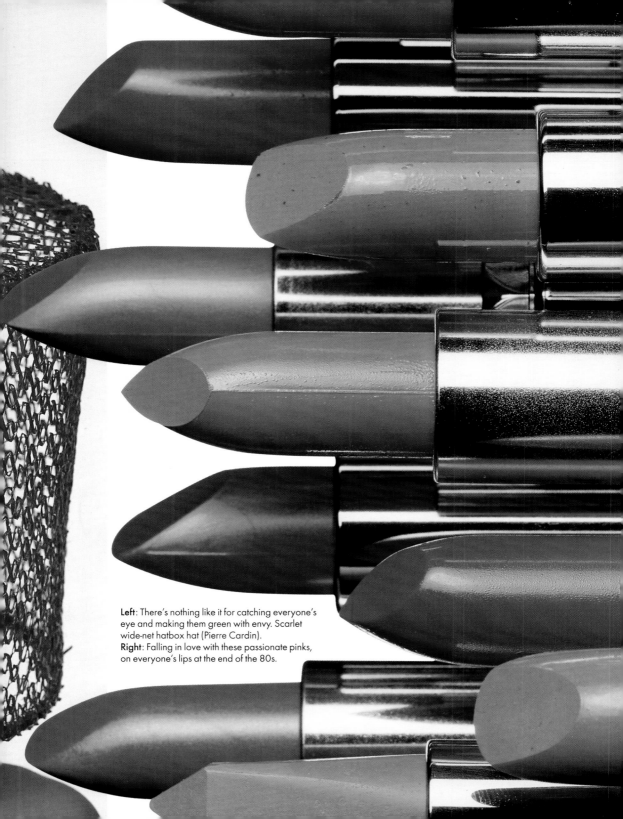

Left: There's nothing like it for catching everyone's eye and making them green with envy. Scarlet wide-net hatbox hat (Pierre Cardin).
Right: Falling in love with these passionate pinks, on everyone's lips at the end of the 80s.

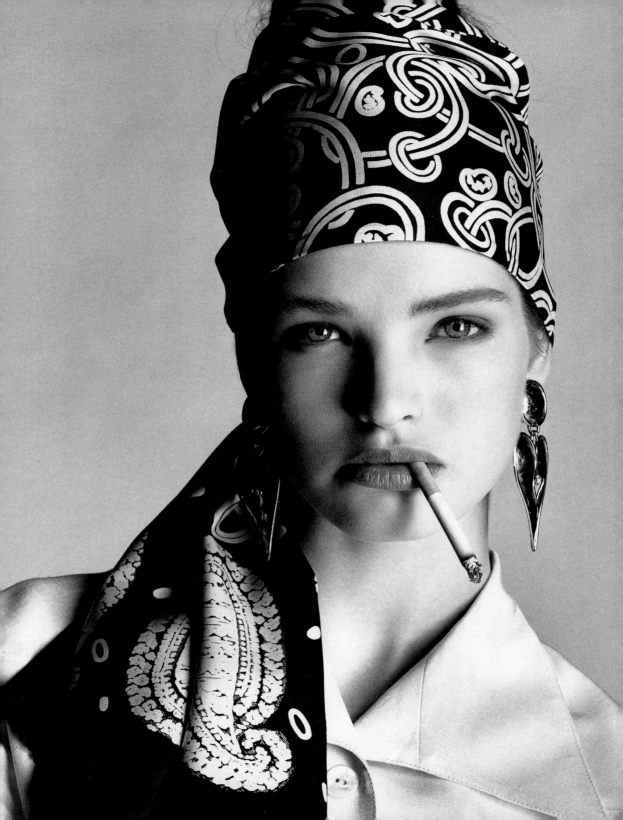

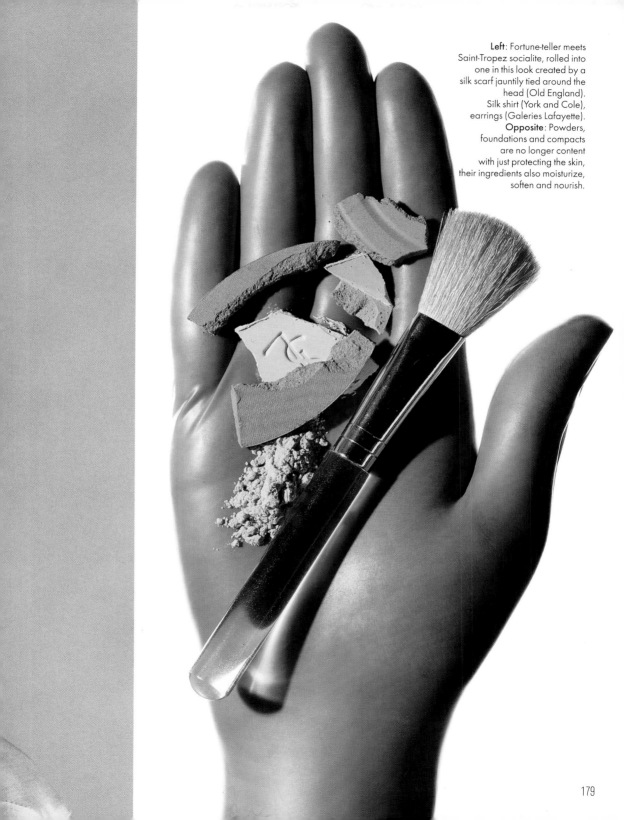

Left: Fortune-teller meets Saint-Tropez socialite, rolled into one in this look created by a silk scarf jauntily tied around the head (Old England). Silk shirt (York and Cole), earrings (Galeries Lafayette). **Opposite**: Powders, foundations and compacts are no longer content with just protecting the skin, their ingredients also moisturize, soften and nourish.

179

Top model Yasmin Lebon showing off a cotton poplin shirt with asymmetrical mandarin collar, topstitched and fastened with a brooch. Corselette skirt accentuated at the waist with a patent leather belt. Long satin gloves (all by Claude Montana).

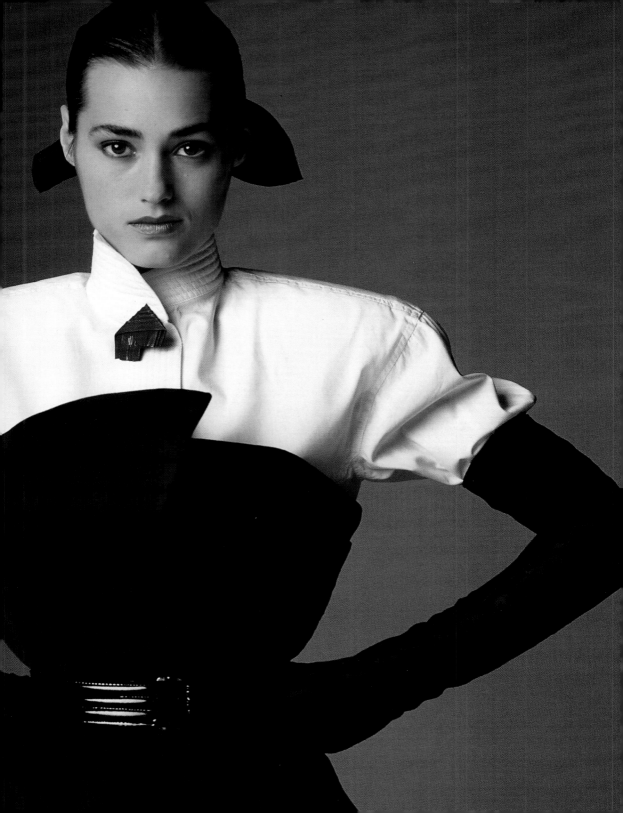

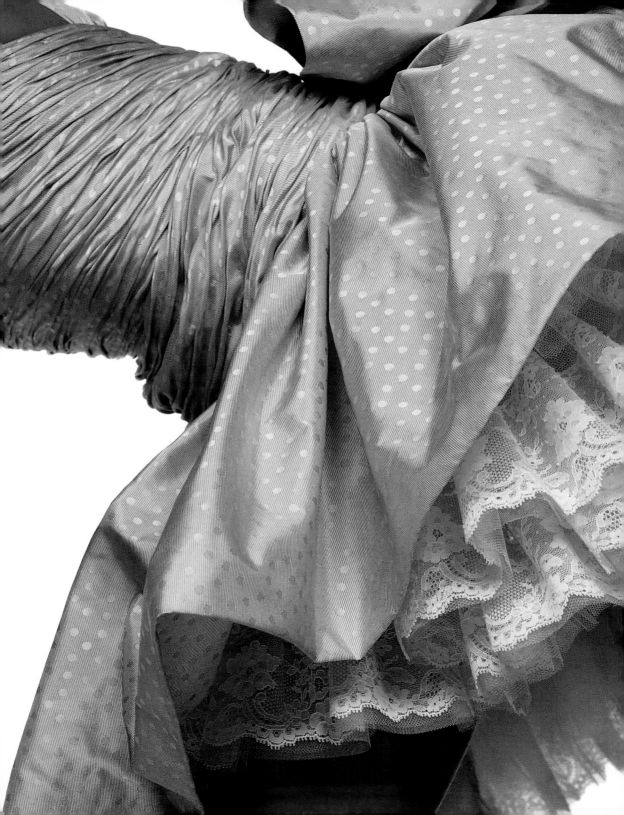

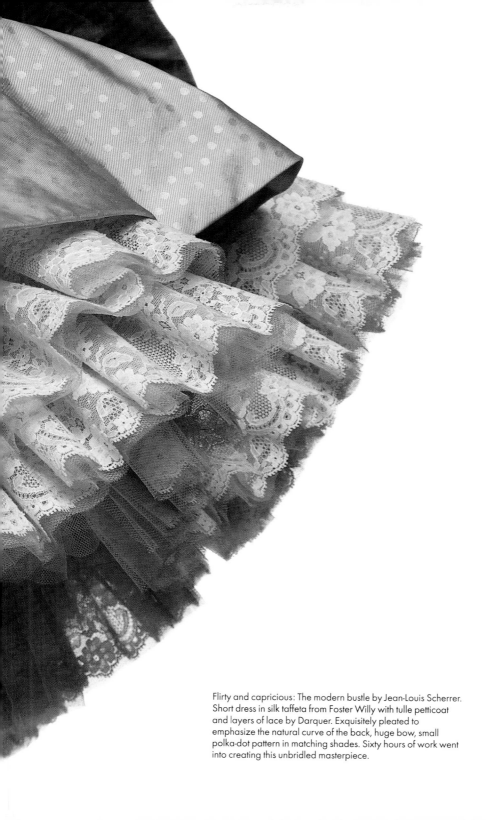

Flirty and capricious: The modern bustle by Jean-Louis Scherrer.
Short dress in silk taffeta from Foster Willy with tulle petticoat
and layers of lace by Darquer. Exquisitely pleated to
emphasize the natural curve of the back, huge bow, small
polka-dot pattern in matching shades. Sixty hours of work went
into creating this unbridled masterpiece.

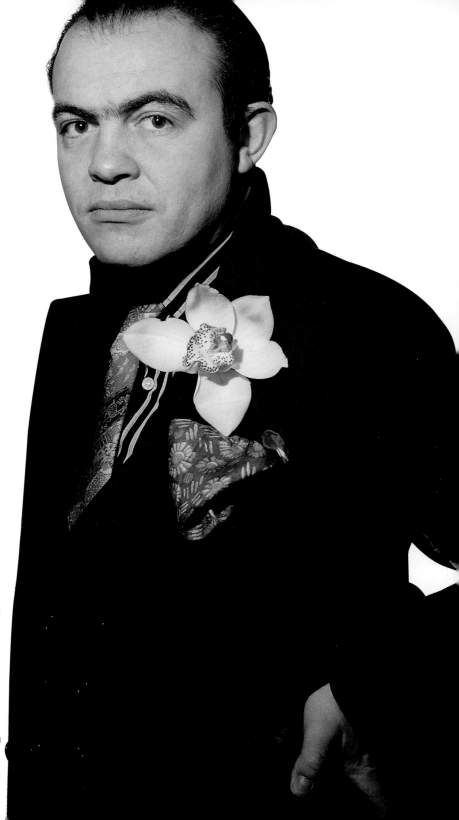

Christian Lacroix

In 1987 the world of haute couture added a new star to its galaxy. Christian Lacroix, the youngest member of his profession, created his first collection under his own name with a youthful and lighthearted eccentricity that has as much influence and impact on fashion today.

Following pages: Thoroughly 80s: pure, harsh, uncompromising colors with a hint of arrogance. A defined figure with shoulder pads and belted waist emphasize the figure (Castelbajac).

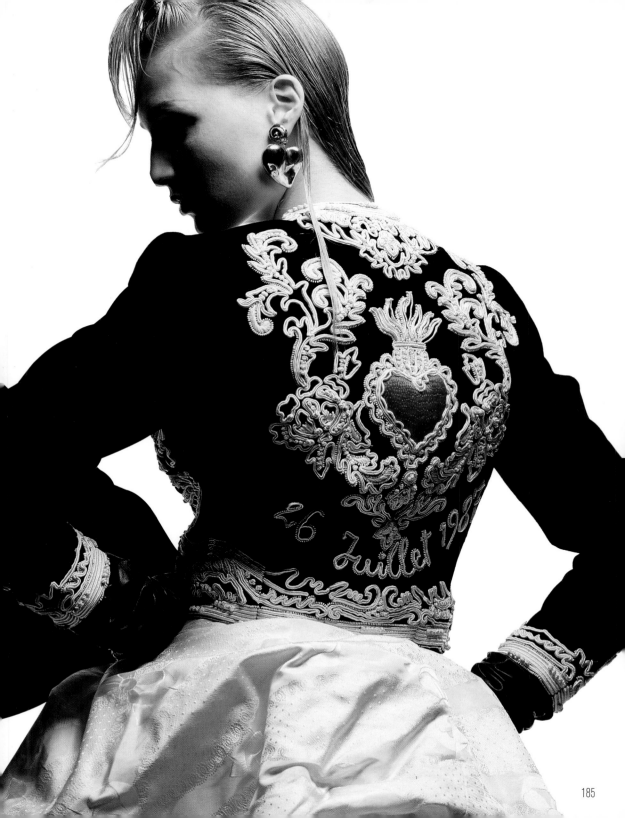

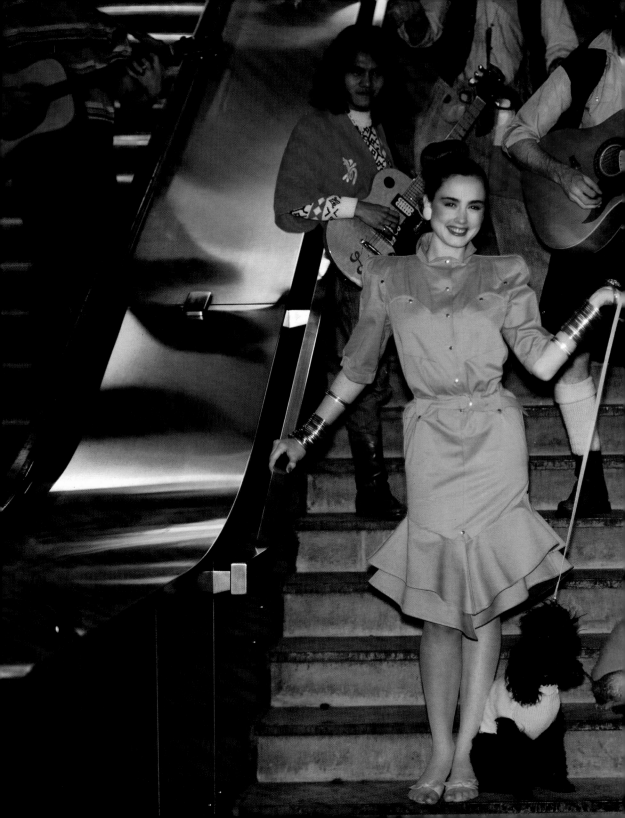

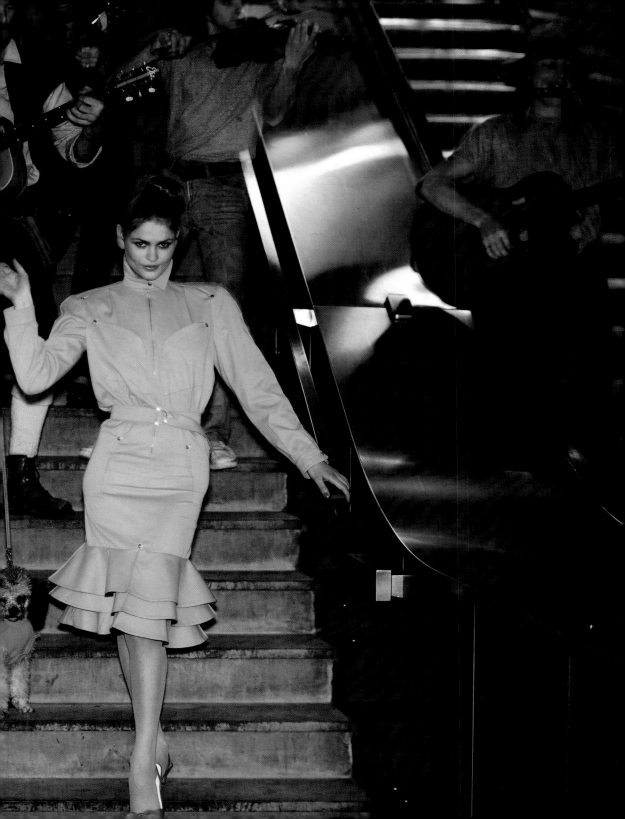

INDEX

PHOTO CREDITS

The publisher wishes to thank for their help Edith Saadi, at French ELLE Phototheque, as well as Laurence Faubel, Claire Faure and Claire Saadi. Thank you also to Barbara Clément, photo editor at ELLE France, Marie-Odile Perulli and Marie-Annick Canu; Agnès Grégoire, associate editor at PHOTO France; Odile Sarron, casting director at ELLE France and Cristina Konstantinou; Mohammed Lounès, at Gamma. And a warm thank you to Florence Rossier.